CELEBRATING
THE
NEGATIVE

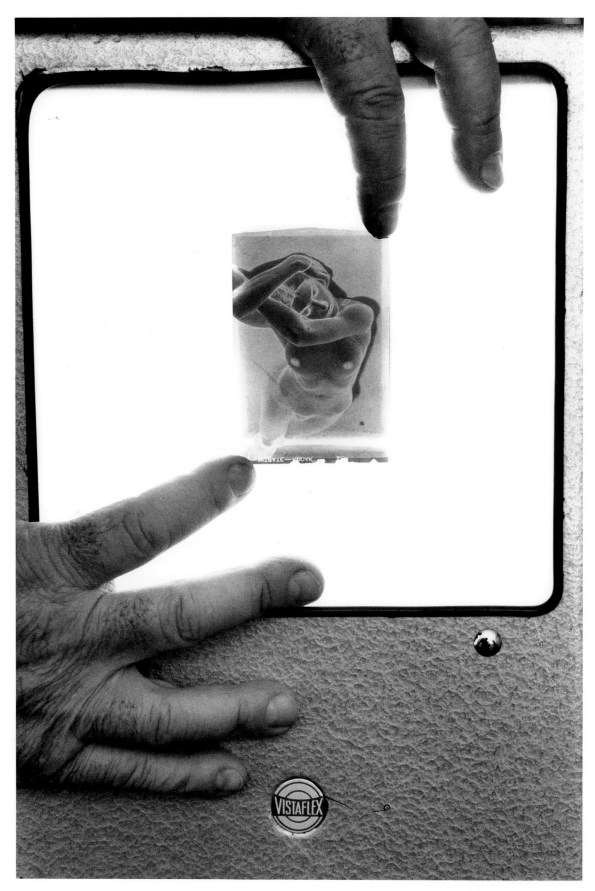

MAN RAY, *Solarization*, 1931, Paris. Hands: Lucien Treillard, 4/26/94.

CELEBRATING THE NEGATIVE

John Loengard

A BOB ADELMAN BOOK

Designed by Bob Cato

Arcade Publishing • New York

(*See page 2.*)
While developing a negative, Man Ray flipped the lights on in his darkroom for a second, purposefully exposing the half-developed film to light. Newly exposed silver salts darkened but refused to blend into areas already developed. Consequently, in the negative, a white line (called the Sabbattier effect) outlines parts of the woman's figure. Man Ray dubbed the effect solarization. That term also describes a reversal of tone in a negative caused by gross overexposure. In prints, the photographer usually included only the model's arms and head. Lucien Treillard, secretary of L'Association Man Ray, held the negative against the screen of a small portable projector for me to photograph.

To: Elizabeth Kalkhurst

Acknowledgments

I am especially grateful to Michael More of the Eastman Kodak Co., whose support has made this book possible, and John Durniak for bringing the book to More's attention. Richard Seaver at Arcade Publishing has provided fine editorial judgment, for which I am no less grateful. James Danziger's interest in the series helped guide it from the start.

I also want to thank everyone who held a negative for me to photograph: Richard Avedon, Miles Barth (at the International Center of Photography), Harry Benson, Noel Bourcier (at the Mission du Patrimoine Photographique), Gilberte Brassai, Harry Callahan, Cornell Capa, Alfred Eisenstaedt, Teresa M. Engle (at the Howard Greenberg Gallery), Marcia Eyerman (at the Oakland Museum of Art), Nat Fein, Andreas Feininger, George Fèvre, Jan Grenci (at the Library of Congress), Yvonne Halsman, Paul Harbaugh (representing the estate of Dmitri Baltermants), Heike Hinsch (at Time Inc.), Yousuf Karsh, Gus Kayafas (executor of the estate of Harold Edgerton), John-Paul Kernot (step-grandson of Bill Brandt), Kevin Kushel (at the Associated Press), Anthony Montoya (at the Paul Strand Archive), Lloyd Morgan, Arnold Newman, Dianne Nilsen (at the Center for Creative Photography), Rondal Partridge, Amy Rule (at the Center for Creative Photography), Sebastião Salgado, Ann Shumard (at the National Portrait Gallery), Lucien Treillard (of L'Association Man Ray) and David Wooters (at George Eastman House).

I am no less grateful to Virginia Adams, Gigi Benson, Noya Brandt, Eleanor Callahan, Estrellita Karsh, Doug Morgan, Joan Munkacsi and Lélia Salgado.

I received valuable help and advice from Michael Hoffman (at the Aperture Foundation); Terence Pitts and Nancy Solmon (at the Center for Creative Photography); James Enyeart, Marianne Fulton and Grant Romer (at George Eastman House); Lucia Siskin, Willis Hartshorn, Phil Block, Suzanne Nicholas and Anna Winand (at the International Center of Photography); Carrie Springer (at the Howard Greenberg Gallery); Dr. Stephen Ostrow, Mary Ison and Bernard Reilly (at the Library of Congress); Louise Blais, Melissa Rombout and Edward Thompkins (at the National Archives of Canada); Drew Johnson (at the Oakland Museum); Pierre Bonhomme (at the Mission du Patrimoine Photographique); and David M. Friend, Maryann Kornely, Debra A. Cohen, Gretchen Wessels, Gail Ridgwell, Helene Veret, Hanns Kohl, John Downey, Tom Stone, Mark Rysin and Lutgardo O. Rodriguez (at Time Inc.).

And Woodfin Camp, Rich Clarkson, Arnold Crane, David Fahey, Judy Fayard, Merry A. Foresta, Nick Graver, Judy Jacobs, William B. Johnston, Hans P. Kraus Jr., Duane Michals, John G. Morris, Jean-Jacques Naudet, Gary Schneider, Kim Sichel, William F. Stapp and Michael Rand.

Picture Sequencing: JILL GILL

Copy Editor: AMELIA WEISS Photographic Prints: HEIKE HINSCH Typesetting: SHEILA BRADFORD

Copyright © 1994 by John Loengard

FIRST EDITION

Library of Congress Cataloging-in-Publication Data
Loengard, John.
 Celebrating the negative / John Loengard. —1st ed.
 p. cm.
 Includes bibliographical references and index.
 ISBN 1-55970-282-6
 1. Photography—Negatives. 2. Photography, Artistic. I. Title.
TR290.L64 1994
771'.43—dc20 94-14301

Published in the United States by Arcade Publishing, Inc., New York
Distributed by Little, Brown and Company

10 9 8 7 6 5 4 3 2 1

PRINTED IN JAPAN BY DAI NIPPON

INTRODUCTION

It is a quirk of nature that silver and chlorine combine in the dark but separate when struck by light, leaving behind tiny, black, round particles of silver.

In 1833 an English gentleman named Henry Fox Talbot coated a sheet of paper with silver chloride and, after putting a leaf on top, left it in the sun so that dark silver appeared everywhere except in the leaf's shape. Under the leaf, the paper remained white. A wash in saltwater stopped the process. The negative was born.

This book celebrates negatives.

It seems to me a collector would want to own the negative from which a famous photograph is printed. Ansel Adams signed more than 800 prints of his *Moonrise, Hernandez, N. Mex.*, during his lifetime, but his negative is unique.

Adams, who was a pianist as well as a photographer, is said to have compared his negatives to a musical score, his prints to a performance. The idea that future master printers might find fresh nuances in his negatives, in the way that musicians interpret Beethoven's symphonies, is tantalizing.

Some negatives show details that are suppressed in prints. For example, when printing his *Moonrise*, Adams would darken clouds until they disappeared; and Henri Cartier-Bresson always crops out the blurred left side of *Behind the Gare St. Lazare.*

Photographers do all this and more. Since light shines through a negative but is reflected off a print, making a print from a negative is a bit like translating a novel from French to English. Such translation is an art, and it is wise to remember that what is translated is the original work of art.

And yet Sotheby's auction house turns down negatives offered for sale. "There's no market for them," a Chicago collector put it. A museum curator told me bluntly, "Collecting negatives would be a very esoteric pursuit. It doesn't exist."

When I read that Robert Mapplethorpe's gallery was selling prints made from his negatives after his death, I expected the gallery would have a different view. Not at all. Mapplethorpe's negatives are "tools of the trade, like an etcher's plate," they said. "They have no value."

However, everyone agrees that one kind of negative *is* collected. It is made on paper using the original process discovered by Talbot in 1833. Talbot's negatives are translucent, not transparent, so they can be viewed by reflected light as easily as prints. In fact, collectors cherish paper negatives and the

vintage prints made from them and often frame them in pairs. In 1989 a paper negative by one of Talbot's friends, the Reverend Calvert Jones, was sold at auction in London for $35,640.

Negatives on glass (beginning in 1851), celluloid (beginning in the 1880s) or plastic need light from behind to be viewed and are therefore not quite as easy to display as negatives on paper. Still, three glass negatives were part of an exhibition at New York's Museum of Modern Art celebrating the 150th anniversary of photography in 1990. One, a 16 x 20 inch collodion glass plate made by Francis Frith in 1857, was on loan to the museum from Janet Lehr, a New York dealer who believes, "The field is as yet under-researched, undercollected. Many negatives are still left with the original sources."

These original sources are often families. Photography itself is only six generations old. The grandchildren, children—even a widow—of some of its earlier practitioners are alive. The paper negative by Reverend Jones that brought a high price at auction was kept by his family for more than a century.

Other families haven't done as well. Alfred Stieglitz left instructions for his wife, Georgia O'Keeffe, to destroy his negatives after his death. "We've lost a great treasure," says Michael Hoffman, executive director of the Aperture Foundation.

In fact, it seems O'Keeffe hesitated some 20 years before doing the deed, but Stieglitz's request brings out an interesting point. Until 1991, when Brett Weston burned some of his negatives on his 80th birthday, there is no record of a prominent photographer choosing to destroy his negatives before his death. Photographers have strong feelings about their film. "If some collector came and offered a lot of money for the negatives of one of my sequences or portraits, I would not sell them," explained Duane Michals. "That's such a horrible thing to do. It's a moment in your life and everything."

Negatives have a character of their own. "Compared to the print, the negative is separate, spontaneous and initial," says James Enyeart, director of George Eastman House in Rochester, N.Y.

If you'd like to buy the negative of Adams' *Moonrise,* it's too late. The negatives of such 20th century American photographers as Adams, W. Eugene Smith and Edward Weston are now kept at the University of Arizona's Center for Creative Photography in Tucson, but they came there almost by accident.

"The original thinking was essentially Adams': collect everything from a photographer's career—diaries, letters, payment ledgers, and so forth. Their negatives just went along with everything else," explains Enyeart, who worked there at the time.

"I used to have a fantasy of camping outside the center in Tucson," says Gary Schneider, a photographic printer in New York. "Of course you couldn't print a Diane Arbus today the way she did in the '60s. The

paper she used has changed completely. You can do something different. Would that be desecrating her picture? I don't know."

In fact, notable prints are frequently made from the negatives of deceased photographers. New prints made from Eugène Atget's negatives (now locked away in the vaults of the Museum of Modern Art) gave flesh to four major exhibitions of Atget's photographs during the 1980s. And Edward Weston's pictures are widely known through prints made by his sons Brett and Cole.

Because there is no market for them, insurance companies list the value of negatives as almost nonexistent. When Paul Strand's negatives were used in printing a book commemorating the 50th anniversary of the National Gallery of Art in Washington, they were insured for only $150 to $200. The prints Strand had made from them were insured for $150,000 to $200,000.

Given the situation, it's not surprising that photographers worry about posterity's handling of their film. "Robert Frank walked in early in 1990 and offered us his," says Sarah Greenough, curator of photographs at the National Gallery. "We have no other negatives, and may never have."

The past 10 years have witnessed an increasing interest in negatives, but there remains a gap between photographers and institutions—and the latter don't always see the future clearly. No museum in 1927 cared about Atget. His work exists today thanks to two collectors, Berenice Abbott and Julien Levy, who bought his archives when he died that year. Nearly a half-century later they sold it to the Museum of Modern Art for a sum Abbott sniffed was "too little."

I don't collect negatives made by others, but I hope others will. Cornell Capa, founding director of New York's International Center of Photography, disagrees. "I don't want collectors to collect negatives," he said. "They'd destroy the negative so the print they own would be more valuable."

But the history of collecting is not one of destruction. I'm reluctant to collect others' negatives because the responsibility is too great. As one photographer pointed out, "When a photographer loses a good print, he's annoyed. When he loses a good negative, he's upset forever."

•

HENRI CARTIER-BRESSON

Behind the Gare St. Lazare, 1932

Paris

Hands: George Fèvre
5/11/87

Actually, I asked Henri Cartier-Bresson to let me photograph another negative showing two prostitutes in Mexico City. They lean through openings in their crib doors. The print is often published.

"Oh, no! No! No! Think of their feelings! They might be grandmothers now. No, no! You can't publish that," he replied with an intensity that surprised me. Instead, he let me see the negative to his most famous photograph. It shows a man leaping into a puddle in Paris. George Fèvre, who prints many of Cartier-Bresson's pictures, put it out on the light table.

In *The Decisive Moment,* Cartier-Bresson described taking it: "There was a plank fence around some repairs behind Gare St. Lazare. I was peeking through the spaces with my camera at my eye. This is what I saw. The space between the planks was not entirely wide enough for my lens, which is the reason the picture is cut off on the left."

For safekeeping, the negative was cut from a strip of 35mm film at the start of World War II. Sprocket holes are missing on one side. Possibly the film was manufactured without them—or possibly someone has cut them off. Asked about this, Cartier-Bresson replies, "I swallowed them."

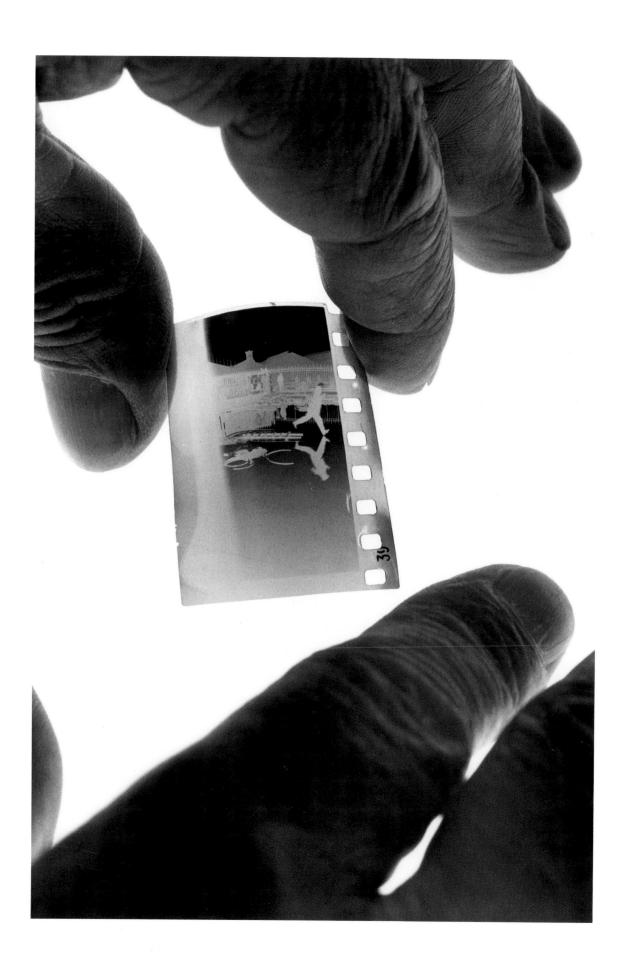

LEWIS WICKES HINE

Dannie Mercurio, Newsboy, Washington, 1912

George Eastman House, Rochester, N.Y.

Hands: David Wooters
3/4/93

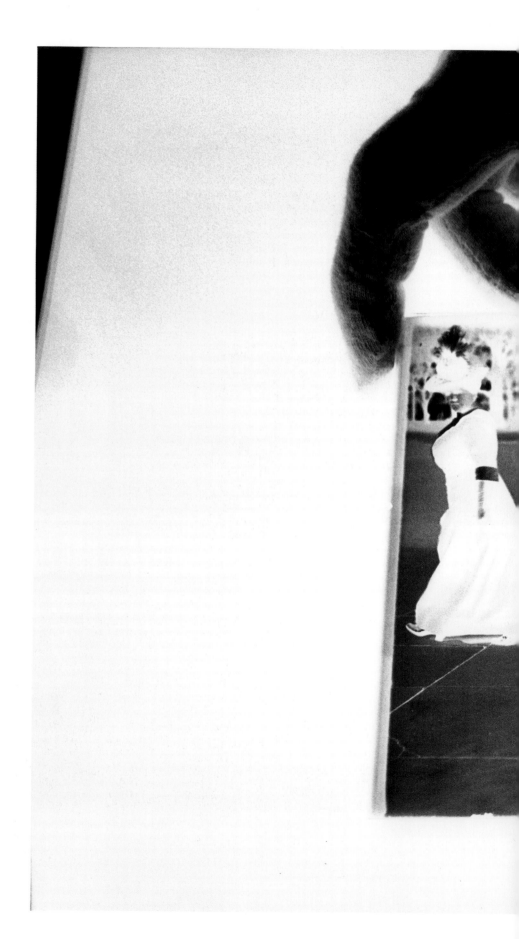

In 1908, five years after he began to take pictures, Lewis Hine quit his post as a botany teacher at the Ethical Culture School in New York City and joined the National Child Labor Committee. For the next eight years he photographed children at work—in factories and mines or, as here, selling newspapers on the street. When Congress passed child-labor laws (in part as a result of Hine's documentation), he continued to photograph working people. "I wanted to show the things that had to be corrected," he said, "[and] I wanted to show the things that had to be appreciated."

Kept by the Photo League in New York after Hine's death in 1940, his negatives (including this broken plate) were passed on to George Eastman House when the league disbanded in 1951.

EDWARD WESTON

Pepper #35p, 1930

Center for Creative Photography,
University of Arizona, Tucson

Hands: Dianne Nilsen
5/15/92

A week after his friend Sonya Noskowiak brought Edward Weston a pepper from the market in Carmel, Calif., Weston wrote in his diary that it was beginning "to show the strain and tonight should grace a salad."

He changed his dinner menu, however, and the next day put the pepper inside a tin funnel to take its picture.

"I have a great negative—by far the best," he wrote after developing his film, adding that the picture had no "psychological attributes, no human emotions are aroused." This was an important point. Friends felt his photographs of vegetables were sexually suggestive, and their comments had annoyed the photographer.

Weston developed several negatives that day, so it is impossible to know for certain which one he thought was the best. He made 25 prints of negative #30, but it is so blindingly anthropomorphic that it can't be the one. Not that it matters. As curator Dianne Nilsen pulled negative #35p (13 prints) from its envelope, I saw that light had arranged particles of silver on its surface with such beauty that it took my breath away.

"It has been suggested that I am a cannibal to eat my models after a masterpiece," Weston wrote that week. "But I rather like the idea that they become part of me, enriching my blood as well as my vision."

MAN RAY

Femme avec Longs Cheveux,
circa 1929

Paris

Hands: Lucien Treillard
4/26/94

Man Ray, born Emmanuel Radnitsky in
Philadelphia, once said his work was
"designed to amuse, bewilder, annoy or
inspire reflection, but not to arouse admira-
tion for any technical excellence usually
sought in works of art. The streets are full of
admirable craftsmen, but so few practical
dreamers."

PHILIPPE HALSMAN

Dalí Atomicus, 1948

New York City

Hands: Yvonne Halsman
10/27/92

While nearly every photographer I've known handles negatives with his bare hands, nearly every curator puts on white cotton gloves. Yvonne Halsman, widow and collaborator of Philippe Halsman, hesitated a moment before I photographed her. She wondered aloud what would look most proper and decided both would.

Forty-four years earlier, her husband and Salvador Dalí had hung one of Dalí's paintings on the right in their studio and then suspended an easel with a blank canvas in the center.

When everything was ready, Mrs. Halsman held up a chair on the left. Two assistants tossed three cats into the air while a third assistant threw water from a pail. Dalí jumped, and Mr. Halsman clicked.

Twenty-six tosses, jumps and clicks later (each followed by floor mopping, cat catching and film developing), they got it right. Mr. Halsman made a print from the 26th negative, and on that print, where the blank canvas appeared, Dalí painted a nude woman supine below airborne cats. Mr. Halsman photographed that print, and the copy was published and became famous. The original negative of the photograph has not been needed since.

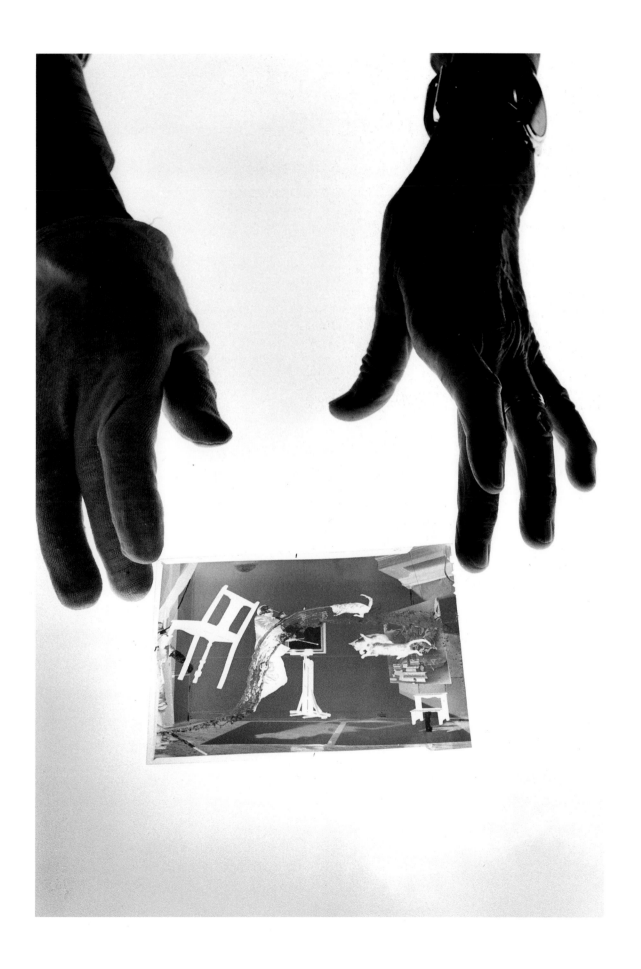

ALVIN LANGDON COBURN

The Octopus, 1912

George Eastman House, Rochester, N.Y.

Hands: David Wooters
3/4/93

"I was fascinated by the natural views from high altitudes such as Mount Wilson and the rim of the Grand Canyon," Alvin Langdon Coburn wrote, remembering a trip he took in 1911. "The following year, I photographed equally fascinating, though quite different, man-made views from the top of New York's skyscrapers."

New York from Its Pinnacles, Coburn's title for the series, included a view of paths radiating from the center of Madison Square. It was taken from Metropolitan Life Insurance's headquarters at 23rd Street.

"At the time, this picture was considered quite mad, and even today it is sometimes greeted with the question, What is it?" Coburn wrote in 1966. "The answer is that it is a composition or exercise in filling rectangular space with curves and masses. Depending as it does more on pattern than upon subject matter, this photograph was revolutionary in 1912."

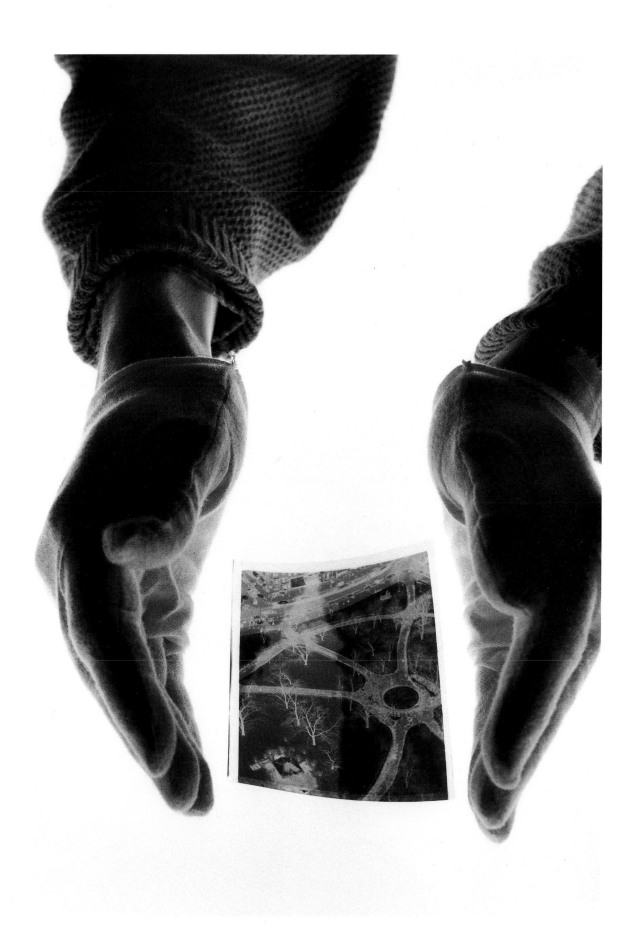

ALFRED EISENSTAEDT

V-J Day, 1945

Time-Life Lab, New York City

Hands: Alfred Eisenstaedt
3/4/92

"I will be remembered when I'm in heaven," says Alfred Eisenstaedt. "People won't remember my name, but they will know the photographer who did that picture of that nurse being kissed by the sailor at the end of World War II. Everybody remembers that." (It's not his favorite picture; he prefers one he took at the La Scala Opera in 1934.)

When the news came of the Japanese surrender in 1945, Eisenstaedt rushed a few blocks from the offices of *Life* magazine to photograph the celebration in Times Square. He spotted one sailor who was kissing everyone in sight—long kisses that allowed a photographer to get off several shots.

But the question is,Which sailor? At last count more than 40 men (some with their lawyers) have claimed to be in the picture. So have at least half a dozen former nurses. Eisenstaedt doesn't know, and the young reporter who was supposed to get the names of those photographed couldn't keep up with the 47-year-old photographer. "I darted through the crowd like a weasel," he says.

Negative editors notched the edges of the film (now covered with transparent tape for safety) to indicate by touch which frames *Life's* darkroom technicians should print on 8 x 10 inch paper and which to make on 11 x 14 inch paper for editors to see the next day.

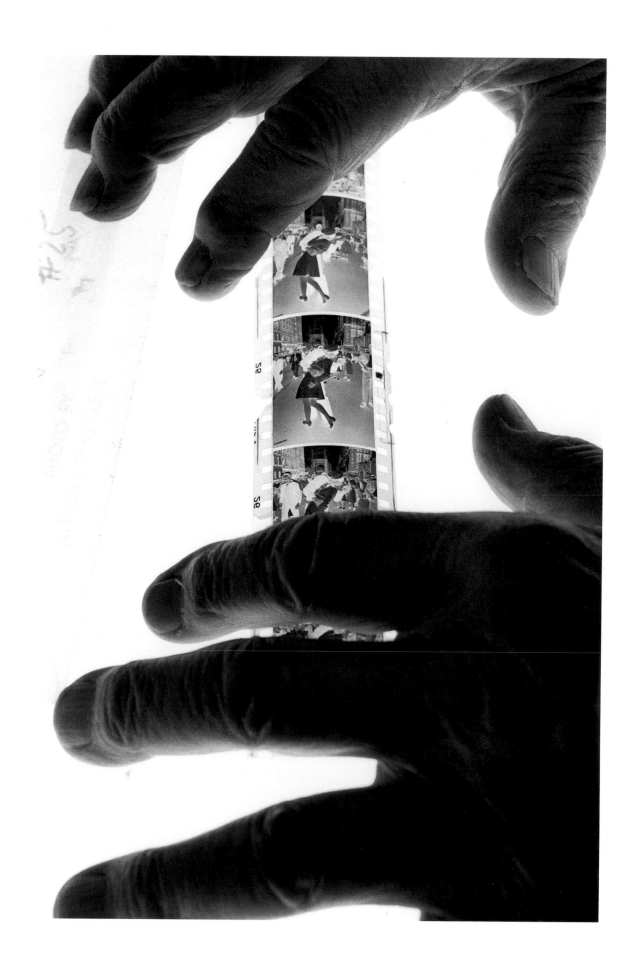

AARON SISKIND

*Pleasures and Terrors of
Levitation (#63), 1956*

Center for Creative Photography,
University of Arizona, Tucson

Hands: Amy Rule
8/20/93

Beginning in 1953, Aaron Siskind photo-
graphed men sprawled against the sky as
they dove or jumped into the water. The sec-
ond frame from the bottom of this strip of
negatives is #63 in the series he titled
Pleasures and Terrors of Levitation.

As the editors of *Minicam* magazine
cautioned when printing a portfolio of Sis-
kind's work, "Documentary pictures are as
often a document to the singular point of
view of the photographer as they may be to
the scene itself."

Or as Siskind put it in 1958, "The
emphasis of meaning [in a photograph] has
shifted—shifted from *what the world looks like*
to *what we feel about the world* and what we
want the world to mean."

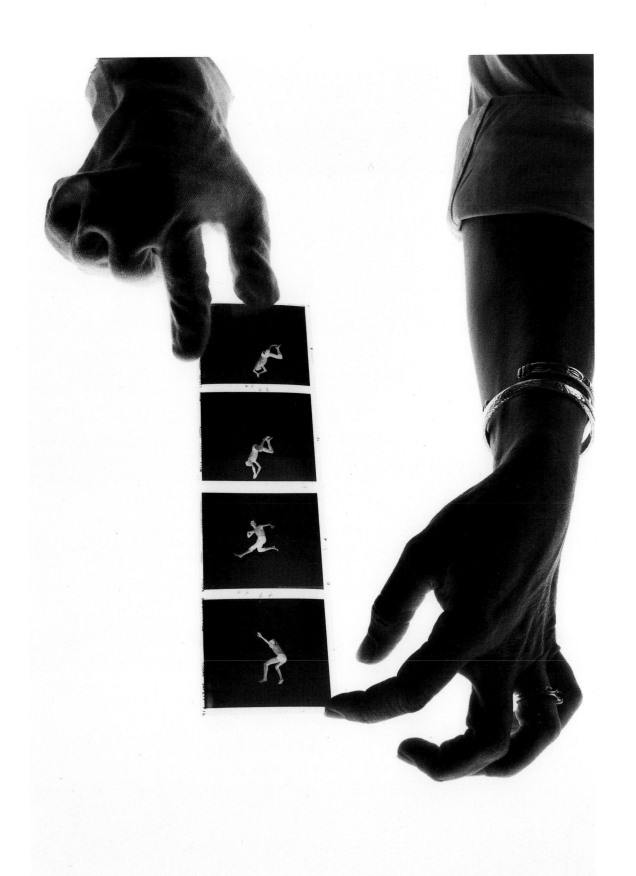

ANDRE KERTESZ

Satiric Dancer, 1926

Mission du Patrimoine Photographique,
Paris

Hands: Noel Bourcier
3/31/93

André Kertész took *Satiric Dancer* in 1926, a year after arriving in Paris from Budapest at the age of 31. He was clowning around with some Hungarian pals in sculptor István Beothy's studio. Dancer Magda Förstner mimicked the host's statuary, and Kertész, with his small glass-plate camera, recorded her jest.

Later in his life, Kertész became allergic to photographic chemicals. Igor Bakht (a Russian who grew up in Tehran, where his father was official photographer to the Shah) made all his prints after 1964.

"If you are not careful printing *Satiric Dancer,* the dress goes black and has no detail," says the 62-year-old Bakht. "I give an extra bit of exposure to the right edge of the negative, and I'll burn in the arms and legs and the lower part of the sculpture with an even longer exposure in order to get a bit of tone and separation there.

"André wanted rich prints, but not too rich. If I'd brought out the clouds too dramatically in a picture, he'd say, 'That's too crafty. I want it slightly on the subtle side.'"

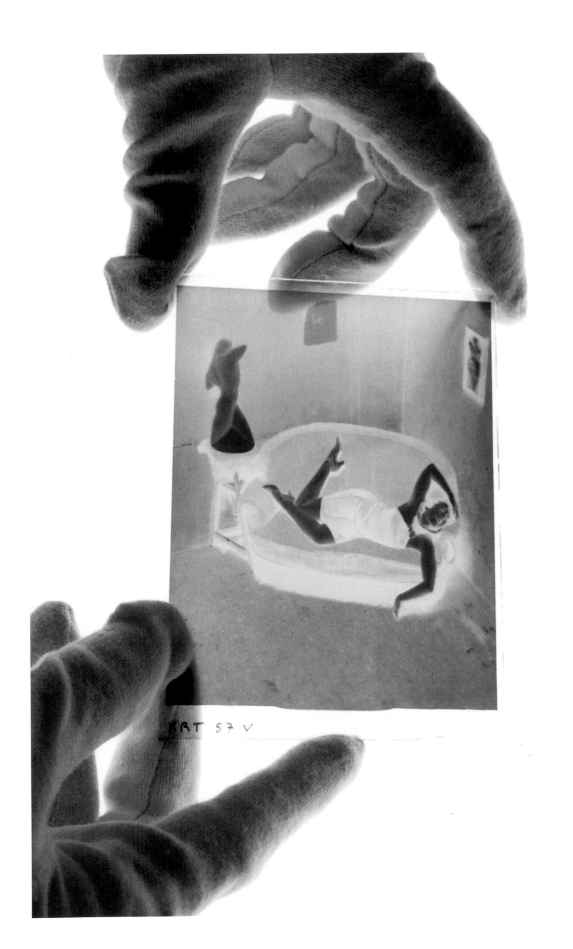

KRT 57 V

IMOGEN CUNNINGHAM

The Unmade Bed, 1957

Oakland, Calif.

Hands: Rondal Partridge
8/17/93

Before I began to photograph his mother's negative of an unmade bed, Rondal Partridge showed me how he removes dirt and scratches from its surface. He dropped one of his own negatives on the wood floor and ground it under his shoe. He picked it up and then began to rub it with Classic car wax. "The fellow who used to print my mother's negatives took four hours to spot [the dust marks from] a pile of finished prints," he explained. "When I wax the negatives before printing them, I can spot a pile in four minutes.

"My prints are cleaner, sharper and better washed [than my mother's]. Their quality, their utility, their prettiness are unchanged. Their longevity is increased. Rarity is the only reason to prefer a dirty old *Unmade Bed* to a new one."

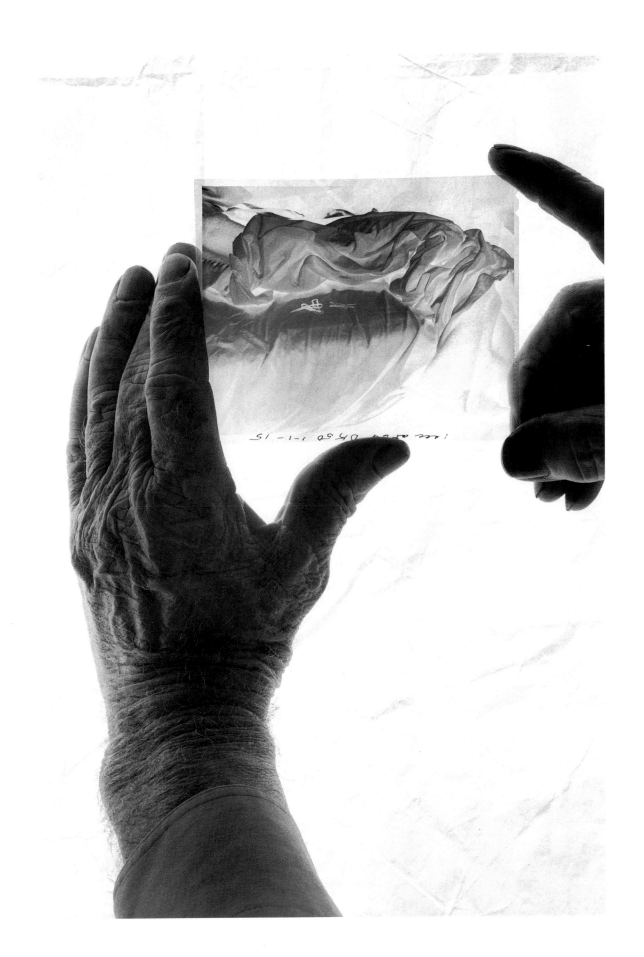

NICKOLAS MURAY

Babe Ruth, circa 1940

George Eastman House, Rochester, N.Y.

Hands: David Wooters
3/4/93

Nickolas Muray, a Hungarian Olympic fencing champion, came to the United States in 1913 and found work as an engraver for Condé Nast. In 1920 he opened a photographic studio of his own in Greenwich Village. For the next 45 years he took portraits of celebrities (at the beginning he did many for Nast's *Vanity Fair* magazine) and photographed for advertising agencies.

Muray had a businesslike attitude toward photography (as this head-on portrait of his fellow athlete George Herman Ruth suggests). "It is *always* the photographer's job to make his pictures as attractive and dramatic as possible," he wrote, adding, "You dream it, we'll photograph it—all in a day's work."

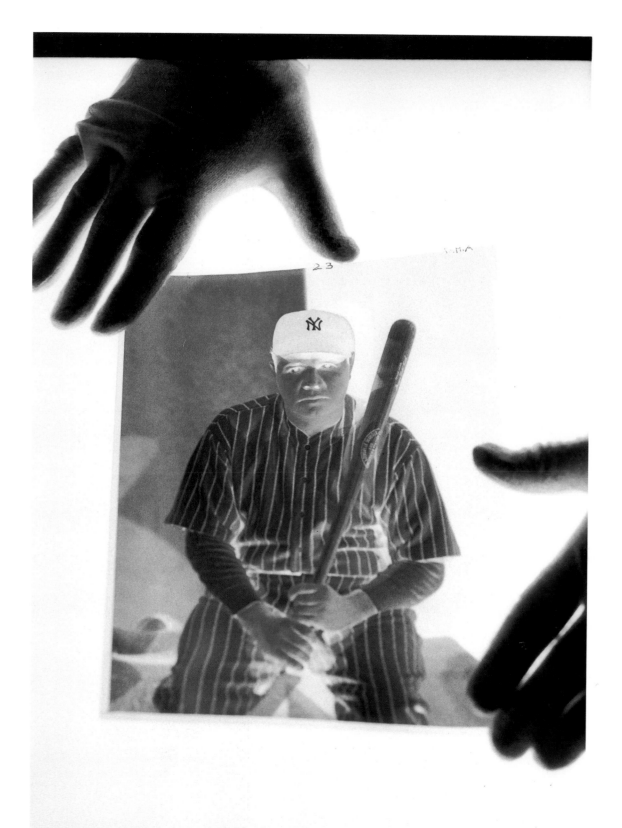

MARGARET BOURKE-WHITE

Buchenwald, 1945

Time-Life Lab, New York City

Hands: John Loengard
3/4/92

"The sights I have just seen are so unbeliev-able that I don't think I'll believe them myself until I've seen the photographs," Margaret Bourke-White wrote in the captions accom-panying her film sent from Germany in April 1945. "Hundreds of dead naked bodies …piles of bones, a gallows, a row of in-cinerators…But worse than the actual dead are the living dead. And Buchenwald is still inhabited by thousands of these."

"I had a deep conviction," she would write later, "that an atrocity like this demanded to be recorded. So I forced myself to map the place with negatives."

Bourke-White used one 2 1/4 x 3 1/4 inch film pack and 11 #120 rolls of film that day—taking about 150 pictures. On the pack's last sheet is the only exposure she made of inmates lined up at a fence outside the camp hospital (red masking has been applied to the negative's edges).

Life magazine's sole story on the liberation of the death camps used two other Bourke-White pictures, both inside a bar-racks. This picture, possibly the most unfor-gettable made that day, was first published in 1960 in an issue celebrating the magazine's 25th anniversary.

"Using the camera was almost a re-lief. It interposed a slight barrier between my-self and the horror in front of me," Bourke-White wrote in her autobiography. When she first saw prints of her pictures, she wept.

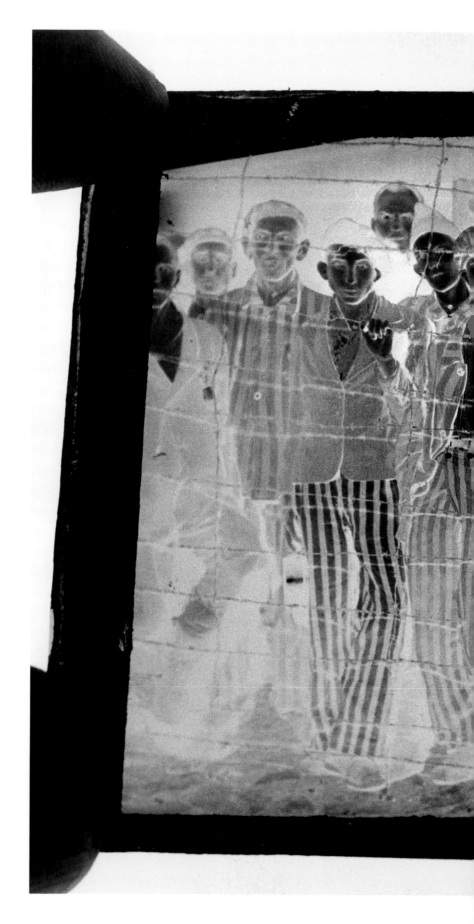

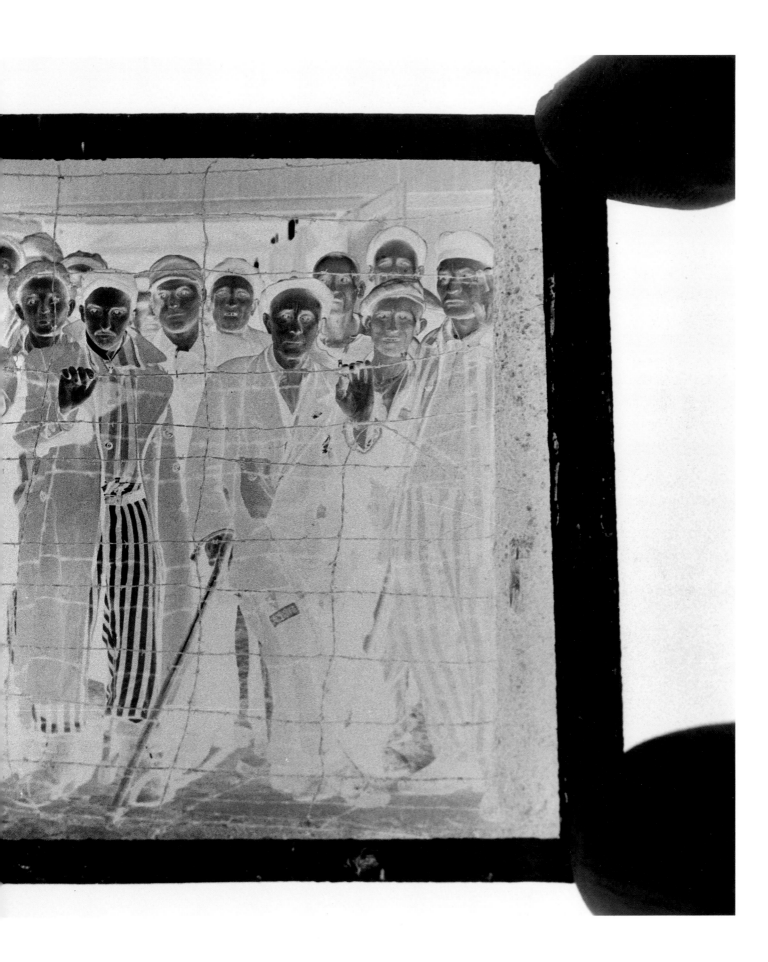

WALKER EVANS

Bud Fields and Family, 1936

Library of Congress, Washington

Hands: Jan Grenci
7/8/92

In the summer of 1936, Bud Field and his family posed for Walker Evans and James Agee, two young journalists from New York City on assignment for *Fortune* magazine to investigate the conditions of tenant cotton farmers in Alabama. Since Evans was on loan from a federal government agency concerned with the plight of small farmers, the government owns his negatives.

Although *Fortune* did not publish the story, Evans and Agee used the material in their 1941 book *Let Us Now Praise Famous Men*. For a later edition, Evans approved dust-jacket copy that read, "If most professional photography is dominated by the commercial stance or artistic posture, Evans is in recoil from these. His work might even be said to have brought photographic style back around to the plain, relentless snapshot."

His *thin*, that is to say, somewhat underexposed or underdeveloped 8 x 10 inch negative remains at the Library of Congress. The negative retains an eerie sense of being present in the "square pine room" where it was made.

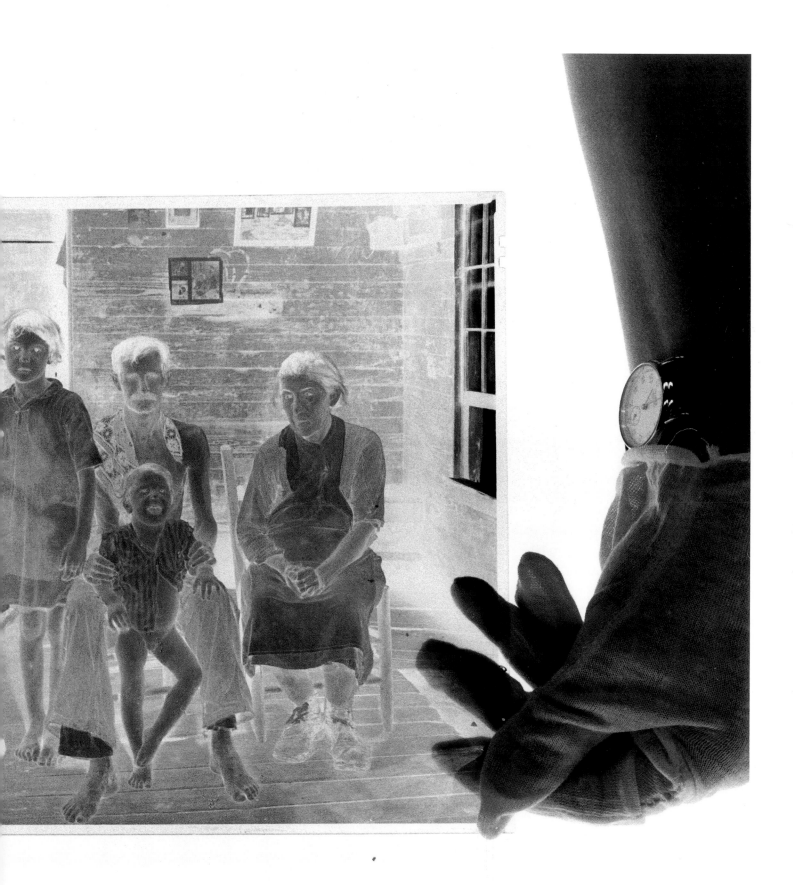

HAROLD E. EDGERTON

Golfer Densmore Shute, 1938

Littletown, Mass.

Hands: Gus Kayafas
2/23/93

Soon after photography was invented, scientists were taking pictures by the light of electric sparks. (Henry Fox Talbot patented a method for doing so in 1851.) In the 1930s Harold Edgerton of M.I.T. devised a way to discharge high voltage through a tube of rare gas, thus creating a spark bright enough to expose film in a millionth of a second.

Edgerton used his lamps to photograph professional athletes. More than 40 flashes, each lasting 1/100,000th of a second and occurring every 1/100th of a second, illuminated golfer Densmore Shute's swing.

Shute could study the photograph to improve his form, but Edgerton wanted to see how a golf club bent after hitting a ball. "A good experiment," he said, "is simply one that reveals something previously unknown."

34

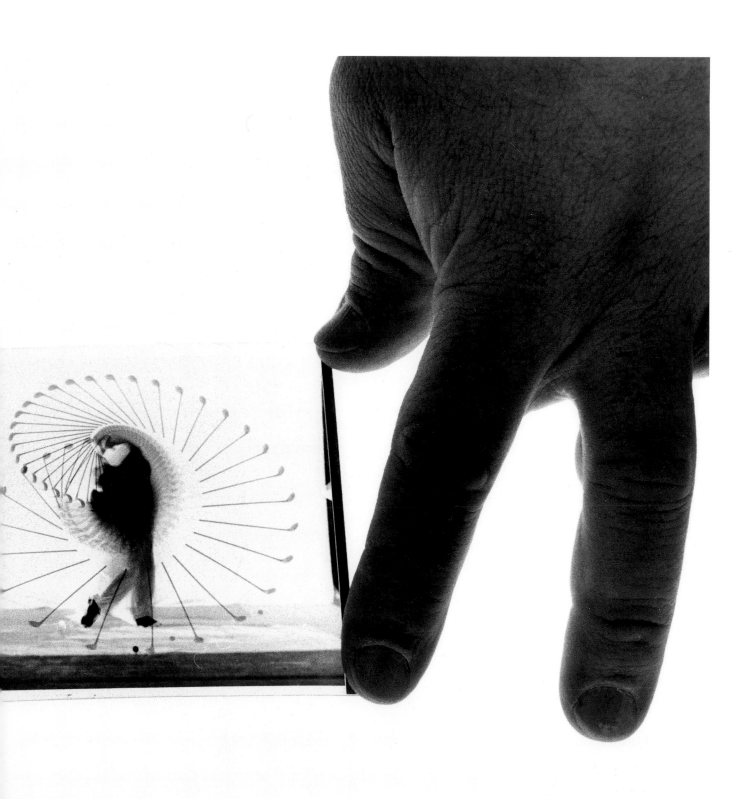

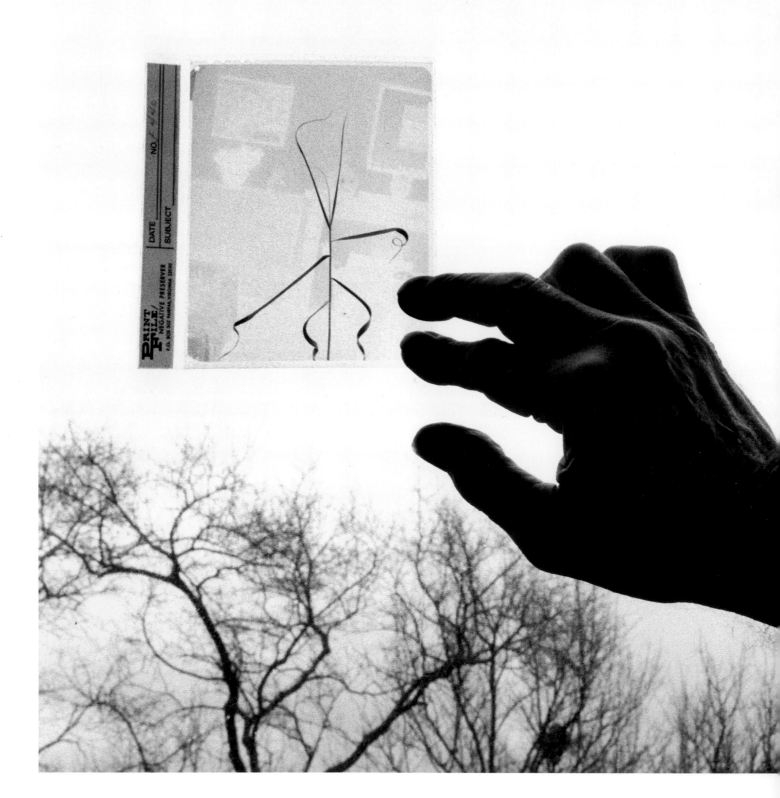

Aix-en-Provence, 1958

Atlanta

Hands: Harry Callahan
2/10/94

"In 1956 I received a $10,000 grant from the Graham Foundation. It was really meant for architects, but none of them could leave their practice and take a year off. I took all my gear and went to Aix-en-Provence," says Harry Callahan, describing his leave of absence from teaching at the Institute of Design in Chicago.

Callahan took his family along. "We had this unbelievably wonderful place to live. [It had] a gardener and his wife and mother, and they sort of adopted us. Everything was so picturesque it seemed you couldn't take a picture."

Even so, one day Callahan photographed a stalk of grass in a vase in the dining room. When making a print of the picture, he exposes the negative long enough for the room's shadowy presence to disappear to black—as he had planned it would.

"In 1976 the Center for Creative Photography bought all my negatives. They agreed to pay $10,000 a year for 10 years, but the negatives don't go there until after my death," says Callahan. "Two collectors in New York paid the same amount for vintage prints, which meant I could stop teaching for good, which was great! Still, when Tucson bought the negatives, it nearly killed me. You know—you *see*—the negative is all I have."

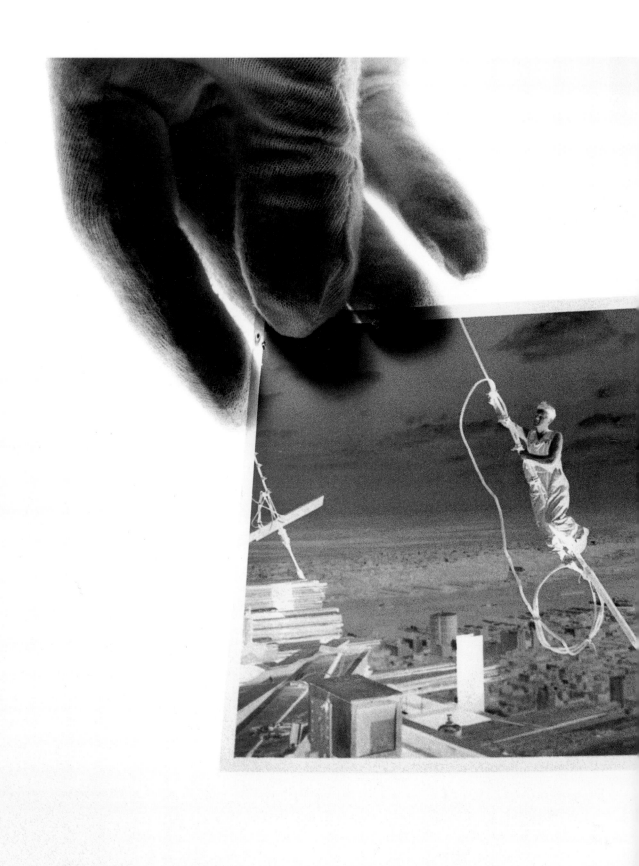

*Icarus atop the
Empire State Building,* 1931

George Eastman House, Rochester, N.Y.

Hands: David Wooters
3/4/93

In 1933 Lewis Hine sent photographs of the construction of the Empire State Building to *Survey,* a magazine that had published his work for 20 years. Its new art director, however, found his pictures old-fashioned. Hine wrote to defend himself against the woman's preference for abstract design: "I have a conviction that the design registered on the human face through years of life and work is more vital for purposes of permanent record than the geometric patterns of light and shadow that serve so often as mere photographic jazz."

DMITRI BALTERMANTS

Grief, 1941

Denver

Hands: Paul Harbaugh
3/13/93

Dmitri Baltermants, the son of an officer in the Czar's army, graduated in mathematics from Moscow University and became a photographer. As a war correspondent for the newspaper *Izvestiya*, he flew into the Crimean town of Kerch in a small artillery-spotter plane. Close by the landing strip, men and women were identifying the bodies of 7,000 villagers executed by retreating Germans.

The pictures Baltermants took were published at the time in Russia and the West, but poorly printed and severely cropped. After the war, Baltermants reclaimed his negatives from *Izvestiya's* archives. In 1967 his print of *Grief* hung at the Metropolitan Museum of Art in New York City, and his fame spread.

Two dots (presumably points where the film stuck together on the reel in the developing tank) mar the sky in the negative. When making a print, Baltermants would hold back the damaged portion and add lowering clouds from another negative. He thus hid a defect while increasing the drama of the picture.

"We photographers make magnificent photographs of war, fires, earthquakes and murder; the grief of humanity," said Baltermants, who became a senior editor at the Soviet magazine *Ogonyok*. "We would like to see photographs about joy, happiness and love, but on the same level of quality. I realize, though, that this is difficult."

ROBERT CAPA

D-Day, 1944

New York City

Hands: Cornell Capa
3/27/93

After landing on D-day's Omaha Beach and spending more than an hour under intense fire, Robert Capa paused to change film. "The empty camera trembled in my hands," he wrote. "It was a new kind of fear shaking my body from toe to hair and twisting my face.

"The men around me lay motionless. Only the dead on the water line rolled with the waves. An LCI braved the fire, and medics...poured from it...I stepped into the sea between two bodies...and suddenly I knew that I was running away. I tried to turn, but couldn't face the beach, and told myself, 'I am just going to dry my hands on that boat.'"

When Capa's film from D-day's bloodiest shore reached London the next evening, Hans Wild (like Capa, a *Life* photographer) saw the negatives fresh from the hypo. He told John Morris, *Life's* London picture editor, that Capa's were the "best pictures of the invasion." Minutes later a young lab assistant burst into Morris' office shouting, "They're all gone!"

Pressured by the picture editor to dry the film quickly and make contact prints for the press pool, the boy had closed the door of the negative drying cabinet, sending the heat inside so high that the emulsion on Capa's film melted. "I held the film in my hand, and it just ran...like pea soup," says Morris, who still feels somehow responsible. Only 11 frames out of 106 could be printed. They were widely published. Cut from the roll for the censors' O.K., three of the negatives (including one of the best) have been lost in the half-century since their rescue.

ANDRE KERTESZ

Meudon, 1928

Mission du Patrimoine Photographique,
Paris

Hands: Noel Bourcier
3/31/93

It is hard to recapture the excitement and sense of freedom that the first 35mm cameras offered photographers who use the events of the streets to make pictures. The large, bulky Graflex camera, introduced in 1902, could capture action well, but it used sheets of film put in place one piece at a time.

In comparison, the small, metal, precision-made Leica wound film on a spool, which halted automatically when fresh film was in place. The camera was ready for use almost continuously. André Kertész bought one of the first in 1928. He used it to take his picture of a curving sidewalk and a railroad viaduct in Meudon, a suburb of Paris. But moments later, as he stepped to the right, a locomotive's passage coincided miraculously with a stranger's errand, and Kertész was able to recompose the scene as quick as a wink.

(Lights in the ceiling of the offices of the Mission du Patrimoine Photographique reflect off the surface of both negatives.)

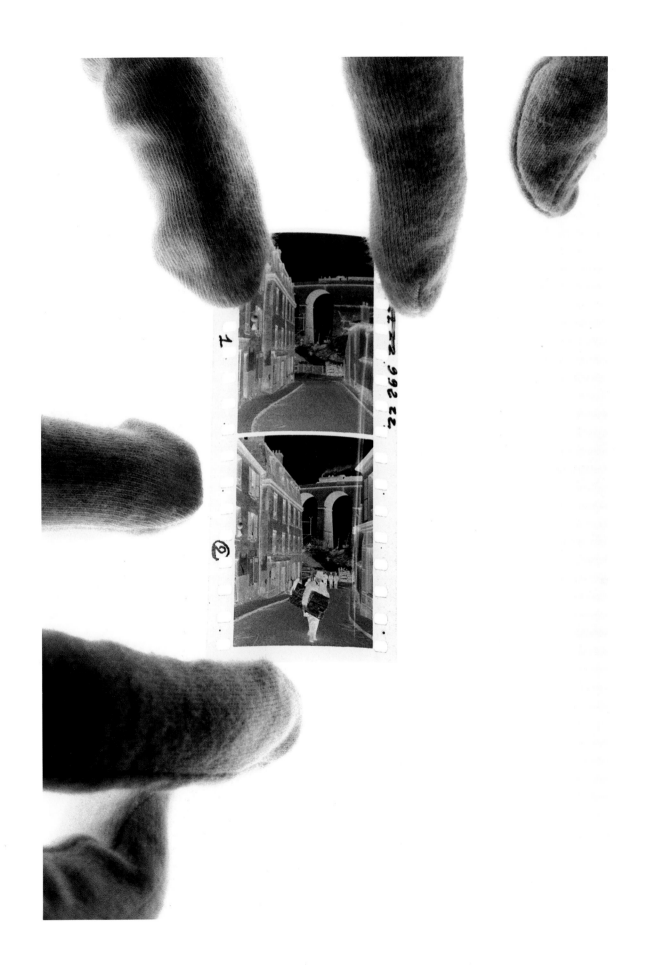

HAROLD E. EDGERTON

Antique Gun, 1936

Littletown, Mass.

Hands: Gus Kayafas
2/23/93

Bullets in motion had been photographed before, in silhouette by the light of an electric spark, but never in full dimension until Harold Edgerton invented his high-speed electronic flash in the 1930s. To study the flight of projectiles, he photographed bullets often.

In this 1936 example, the slug is obscured by the gases that preceded it from the muzzle of an antique pistol. A microphone, visible at the bottom of the negative, caught the sound of the shot and triggered the light.

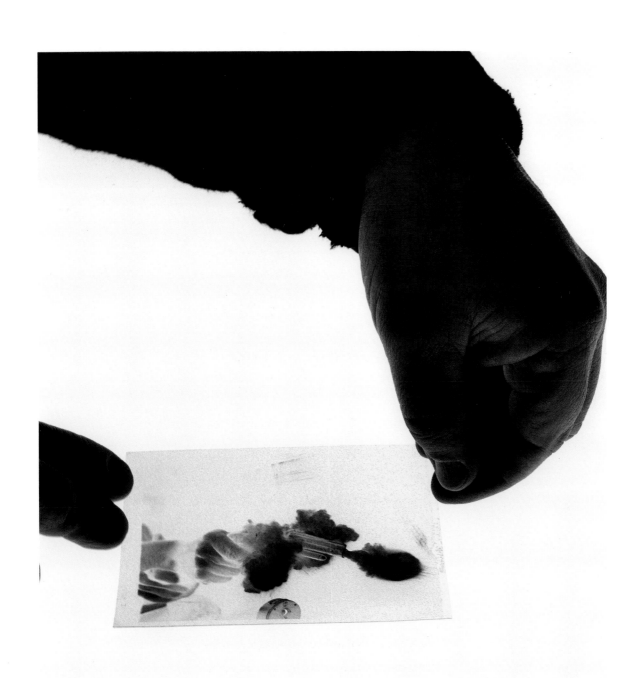

JACQUES-HENRI LARTIGUE

Avenue des Acacias, 1911

Mission du Patrimoine Photographique,
Paris

Hands: Noel Bourcier
3/31/93

"Papa is like God (as a matter of fact, he might even be God in disguise)," wrote seven-year-old Jacques-Henri Lartigue in his journal for 1901. "He's just told me, 'I'm going to give you your own camera.' Now I will be able to make portraits of everything... *everything*."

Lartigue's 5 x 7 inch camera was replaced by a portable model when he was 10. At 16 (a year before recording this example of *la belle époque* on Avenue des Acacias), he wrote, "Women... everything about them fascinates me."

When he grew up, Lartigue painted women's portraits professionally and kept photography as a hobby. The year I first met him, he liked to say with accuracy, "I'm seven years old—plus 80." He also said, "I don't photograph anything I don't like. I do the flowers. I don't do the weeds."

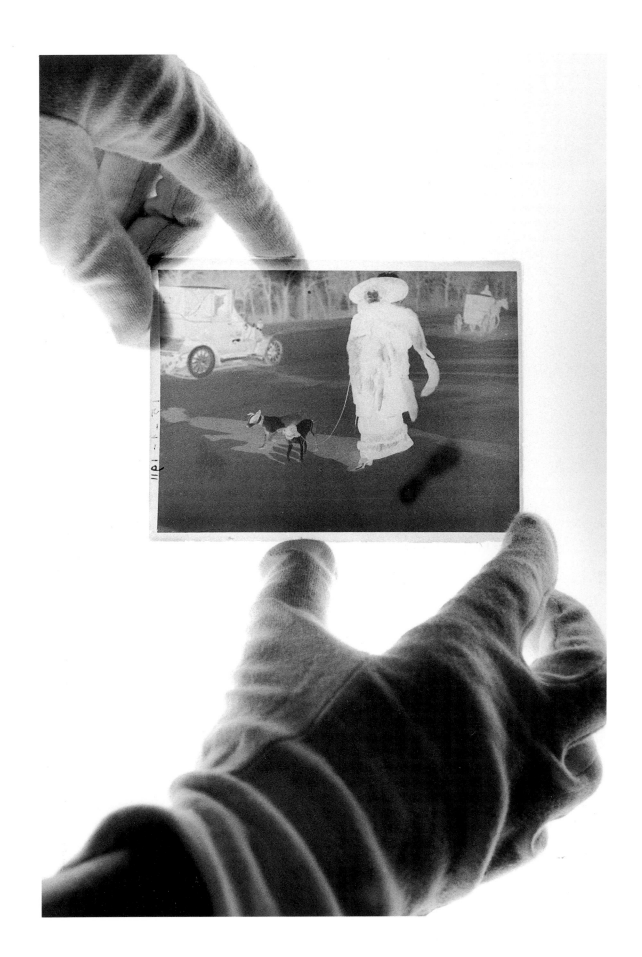

ANDREAS FEININGER

Helicopter, 1949

Time-Life Lab, New York City

Hands: Andreas Feininger
11/3/92

The Navy put lights on the rotor blades of a helicopter used in night missions and called in the press to show off its innovation. After newspapers had published their photographs, *Life* magazine's picture editor asked Andreas Feininger if he thought he could do better.

"Of course," Feininger replied.

The Navy brought the helicopter out again, and Feininger talked to the pilot. He asked him to lift off, fly forward a bit and then go straight up. That way, Feininger imagined, he could fill two pages of the magazine.

Positioning himself opposite the moon, Feininger opened the camera's shutter and fired a flash to illuminate the chopper. Then he let the lights on the rotor blades trace a spiral on the negative as the craft took off.

"The effect," Feininger noted, "was like Santa Claus going up the chimney."

EISENSTAEDT

né Breguet, 1932

New York City

Eisenstaedt
92

When the *Berliner Illustrieter Zeitung* asked Alfred Eisenstaedt to go to St. Moritz, Switzerland, to see how the rich and famous were spending the winter of 1932, its editor, Kurt Korff, told Eisenstaedt to take pictures filled with action—"like Munkacsi's." He also told him not to use a 35mm camera. A bigger negative, Korff thought, produced better pictures.

Eisenstaedt borrowed a chair from an empty table at the Grand Hotel's outdoor restaurant and focused his 6 x 9 centimeter Miroflex camera on it. (The camera had no focusing scale.) As a waiter skated by, Eisenstaedt took one picture. "Of course, I took only one. In those days everything was so heavy. My pockets were filled with glass plates. I couldn't afford to take more than one," he says.

Never a slave to captions, Eisenstaedt didn't get the waiter's name. In 1966 an elderly woman approached him at an exhibition of his work in New York City. "That's my husband," she said. Eisenstaedt has titled the picture *Headwaiter René Breguet* ever since.

In the 1950s, someone in *Life* magazine's darkroom, while printing Eisenstaedt's early work, broke the glass plate in two. This was not the calamity it might have been since Eisenstaedt crops the picture close to the waiter. Still, he has taped the broken glass back together.

ANDREW JOSEPH RUSSELL

Meeting of the Rails at Promontory Point, 1869

Oakland Museum of Art,
Oakland, Calif.

Hands: Marcia Eyerman
11/9/93

In 1844, Asa Whitney, a New Yorker, suggested that the federal government sponsor a transcontinental railroad to speed travel to the Far East. Congress surveyed routes and listened to pitches from various towns and territories before deciding that the Central Pacific Railroad should build east from San Francisco while the Union Pacific would build west from Chicago. The rails met at Promontory Point, Utah, on the 10th of May, 1869, in a photo opportunity.

California sent a golden spike, and A.J. Russell, who had made photographs as a captain in the Union Army, set up his camera with its 10 x 13 inch glass plates. After the speeches, according to historian Barry B. Combs, the Union Pacific's engine *No. 119* (right) moved over the spot where the spike was placed and close to the Central Pacific's locomotive *Jupiter*, which sported a wide funnel designed for engines burning wood. Grenville M. Dodge (left) and Samuel S. Montague, the two chief construction engineers, shook hands.

For most of a century, this picture was attributed to another photographer, but handwriting at the top of the negative clearly identifies the wet plate as Russell's.

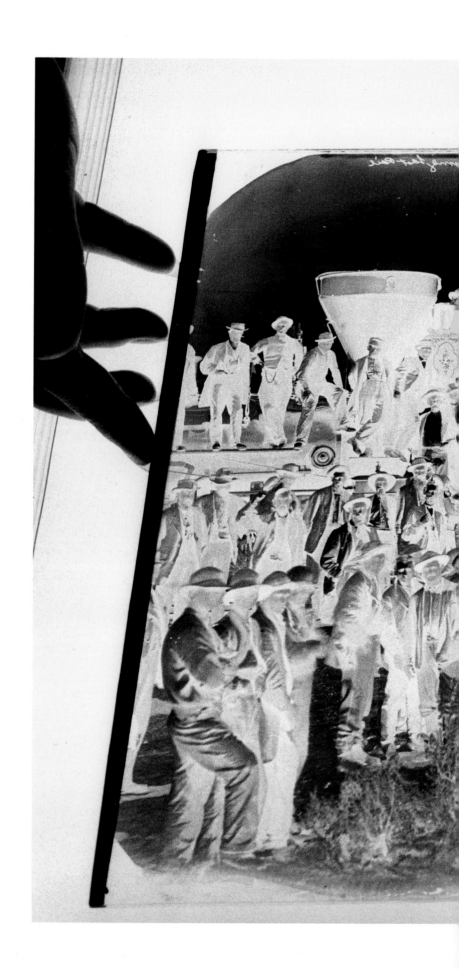

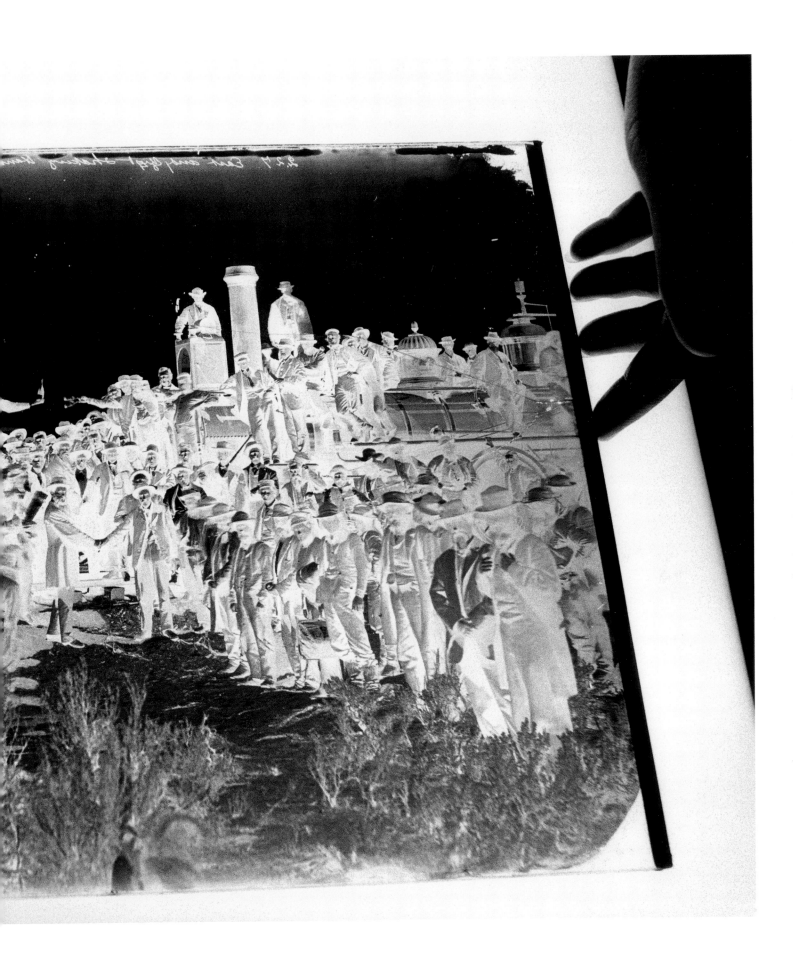

NAT FEIN

Babe Ruth Farewell, 1947

Tappan, N.Y.

Hands: Nat Fein
12/21/92

"Number 3 was the thing I was interested in. I felt the only way to tell the story of Babe retiring was from the back. They retired the uniform that day so no other player would ever wear it again," said Nat Fein, who joined the New York *Herald Tribune* in 1934 when he was 20.

"The picture editor told me not to use flashbulbs if I could help it, so I handled my 4 x 5 inch Speed Graphic like a small candid camera. That day there was an Associated Press photographer standing next to me, but he held his camera vertically. He also popped a flash. When you do that, the foreground is light and the background goes dark. It didn't work nearly as well." Fein's photograph won a Pulitzer Prize.

"It was a wonderful way of working at the *Trib*. We all printed our own negatives and kept them in our own files. When the paper folded in 1966, I could just take them with me."

ARNOLD NEWMAN

Igor Stravinsky, 1946

New York City

Hands: Arnold Newman
4/12/94

"When you handle something as valuable as this, you should wear gloves," says Arnold Newman, referring to his negative taken on assignment for *Harper's Bazaar* magazine in 1946.

"Stravinsky was visiting New York, and I didn't want to photograph him in a hotel room. An editor at the magazine had an apartment with a piano. I went up and looked. It was perfect. I had to put up a 1,000-watt lamp on the left, but that was it.

"I had this idea: the top of an open piano looks like a half note. Its shape is strong. It's linear. It's quite beautiful—it looks the way Stravinsky's music sounds.

"I was 98% sure I knew how the final picture would look. I knew I'd cut off most of the top and bottom of the negative in the print, but I wasn't certain about including Stravinsky's right hand. That's why I had him put it where it is. In the end, I cut it out too."

A shortage of space in the issue (all they told Newman was, "It will not look good small") led *Bazaar* to reject the photograph, returning it to the photographer to sell elsewhere, which he has done. It is his most often reproduced photograph.

59

YOUSUF KARSH

Winston Churchill, 1941

National Archives of Canada,
Ottawa

Hands: Yousuf Karsh
2/16/94

"When I am with a camera, I feel I am the most important person in the world," says Yousuf Karsh, describing his first encounter with Winston Churchill, on Dec. 30, 1941.

Leaving the floor after addressing Canada's Parliament, Churchill was surprised to find Karsh in the Speaker's Chamber, prepared to take his portrait. The photographer stepped up to remove a freshly lighted cigar from Churchill's lips. "It was an act of reverence, as I would shoo a fly off a person's coat before I photographed him. By the time I was back at my camera, he was looking as belligerently at me as if he could have devoured me," wrote Karsh, who took the picture anyhow. He adds, "I was very happy with myself when I left the building. I knew I had it."

Karsh crops out Churchill's elbow in prints—as well as most of the chair and the upper part of the wall. As a result, he says, he's never noticed the three odd-looking black lines that appear on the negative, high above Churchill's head and to the left.

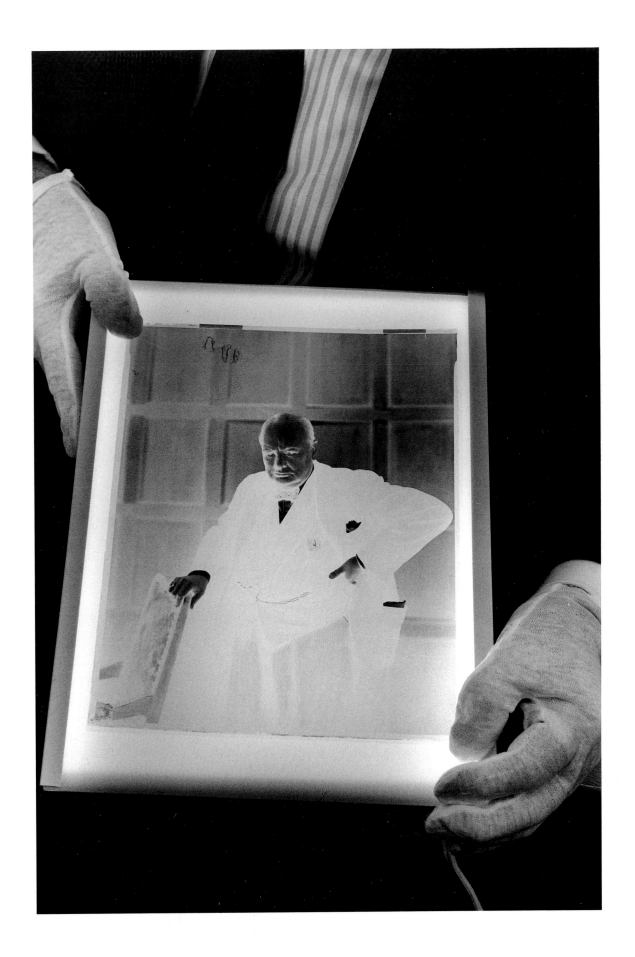

ALEXANDER GARDNER

Abraham Lincoln, 1863

National Portrait Gallery,
Washington

Hands: Ann Shumard
10/15/92

On Aug. 9, 1863, the day before Alexander Gardner opened his new studio at 7th and D streets, Abraham Lincoln came in to pose. Pictures from the session were used by the President in his 1864 campaign for re-election.

Sometime in the 1870s, another studio owner, Moses P. Rice, acquired the 20 x 17 inch glass wet-plate. An original negative had commercial value because photographers sold pictures of celebrities directly to the public—until the half-tone method of reproducing prints was perfected in the 1890s.

Rice applied tape to form a neat border when printing the picture in contact with photographic paper. The tape may also keep the collodion emulsion from separating from its glass support. Rice's granddaughter sold the plate to the National Portrait Gallery at the Smithsonian Institution in 1983. To avoid damaging its collodion surface, Ann Shumard at the Portrait Gallery put the negative out for me on a light box with its emulsion side up. Seen this way, the image is backwards.

"A lot of 19th century glass was chemically unstable. It embrittles over time, becoming even more fragile than glass normally is," says William F. Stapp, who exhibited the plate in 1990 when he was the curator of photographs at the Portrait Gallery. "I held my breath till we got the negative safely into the display case we had spent weeks designing."

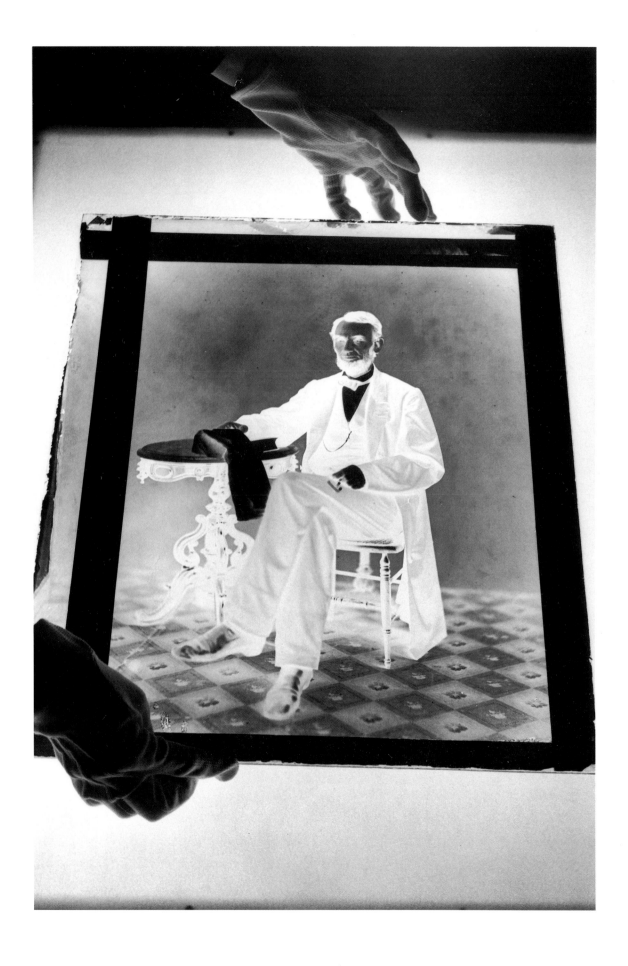

RICHARD AVEDON

Ronald Fischer, Beekeeper, 1981

New York City

Hands: Richard Avedon
5/3/94

Even before Richard Avedon started his project *In the American West* in 1979, he planned to photograph a man covered with bees. He advertised for a subject and found Ronald Fischer, a Chicago banker and amateur beekeeper. After queen-bee pheromone was applied to his skin (to attract drones), the tall, shaven-headed Fischer stood patiently outdoors in Davis, Calif., while Avedon ran through a stack of 8 x 10 inch film holders, and they both got stung.

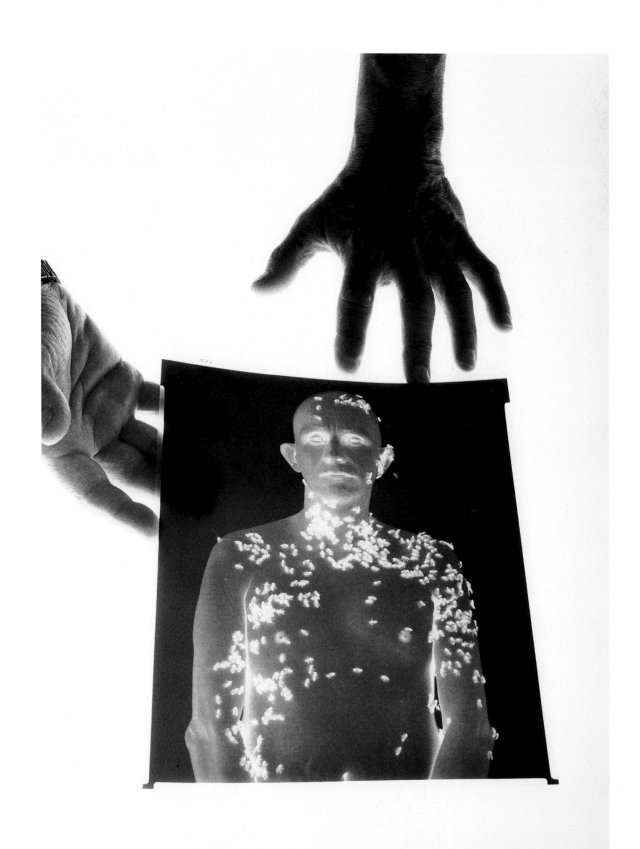

YOUSUF KARSH

George Bernard Shaw, 1943

National Archives of Canada,
Ottawa

Hands: Yousuf Karsh
2/16/94

In England, Lady Astor arranged Yousuf Karsh's appointment with George Bernard Shaw. On arrival at the playwright's home, a secretary told the photographer he would have only five minutes with Shaw. He could use no lights, move no furniture, and the photograph had to be taken in front of the fireplace. Also, he must use a miniature camera. To begin with, Karsh suggested politely that a plainer background might be better...

Fifty-one years later, Karsh smiled as an archivist brought the negative of Shaw out. "I think it's one of the most subtle negatives ever made in photography—at least one of the most subtle I've ever made," he said. "Of all the work I've done, it's one of the best. All the beautiful transitions from light to shadow are there. It's just very exquisite."

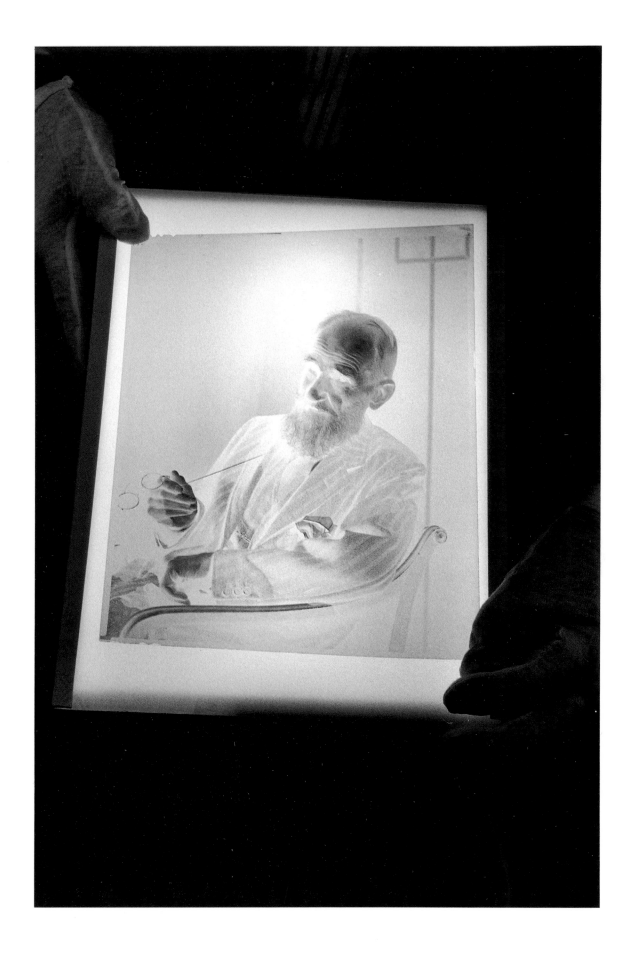

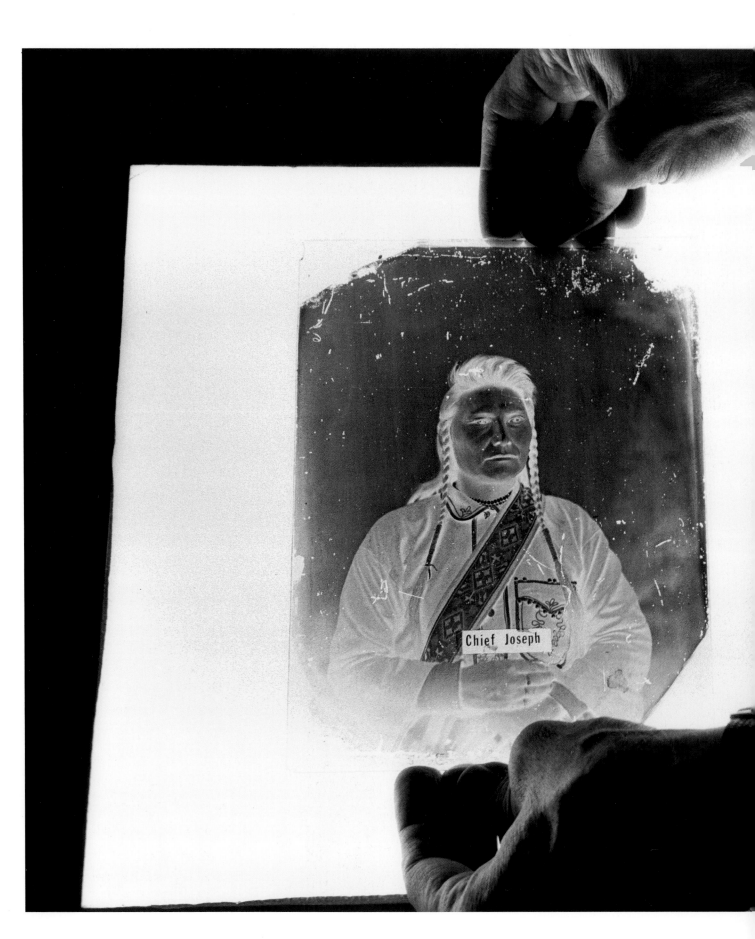

ORLANDO SCOTT GOFF

Chief Joseph, 1877

Western History Department,
Denver Public Library,
Denver

Hands: Paul Harbaugh
3/13/93

In 1877, Orlando Scott Goff, an itinerant photographer working at Fort Abraham Lincoln, in the Dakota Territory, photographed a Native American, Chief Joseph. For three months the 35-year-old leader of the Nez Percé had led 750 of his people in an escape from their Oregon reservation. After winning several battles with the U.S. Army during their 1,300-mile trek, the Nez Percé were captured at Bear Paw Mountain in Montana, 40 miles from the Canadian border and freedom.

Postcard-size prints of celebrities like Chief Joseph (about whom there was interest back East) were profitably circulated. For ready identification, the subject's name was printed on onionskin paper, which was attached to the negative before the card was printed.

Later, Goff sold his wet-plate negatives to his assistant, David F. Barry, and moved on to Haver, Mont., where he served a term in the state legislature. In 1934 Barry, needing a few hundred dollars, sold all his negatives (and Goff's) to the Denver Public Library.

Magnolia Blossom, 1925

Oakland, Calif.

Hands: Rondal Partridge
8/17/93

Imogen Cunningham educated herself about plants and flowers after she began to photograph cacti and other succulents in her backyard in Oakland, Calif.

"Her *Magnolia Blossom* is great, but she made a hundred magnolias—literally 100 negatives of magnolias—that she threw away," says her son Rondal Partridge. "When we were kids we used to throw her rejected negatives into the fireplace—the nitrate would explode—hundreds, thousands. God, how I wish we hadn't."

"For a long time I did not think my mother was a very good photographer. She was just a photographer. She did portraits and kids. She *assumed* her job was every day to make a photograph, but she photographed for the pure joy. She considered it not her work—it was her occupation to make people see and be happy."

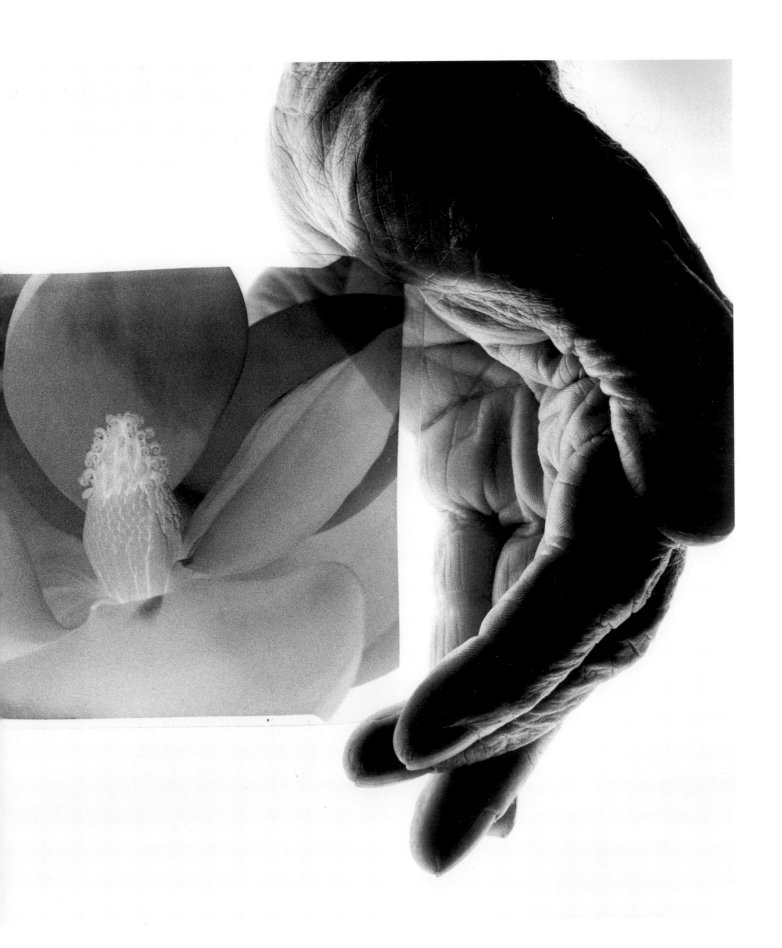

MARTIN MUNKACSI

Dancers in Seville, 1930

Howard Greenberg Gallery,
New York City

Hands: Teresa M. Engle
1/12/94

Negatives to many of Martin Munkacsi's most famous photographs are missing. He may have left some behind during his sudden departure from Berlin in 1934. An editor, newly appointed by the Nazis, refused to reimburse Munkacsi for bananas used in a still life because they were not "Aryan fruit." The 38-year-old photographer abruptly decided to accept *Harper's Bazaar* magazine's offer to photograph fashion in the United States.

Munkacsi asked models to run, leap and jump—startling innovations in fashion photography at the time. He became one of the most highly paid photographers in America.

After he died of a heart attack while watching a soccer game in New York City in 1963, his photographs were sent to a warehouse. While there, some glass plates were broken and other negatives disappeared. Among his surviving glass plates is this example of a lifelong fascination with figures in motion.

"Only who and when can be covered in the caption," Munkacsi said. "The what and why must be in the photograph itself." That's good advice and useful here. All that is known about this picture is that Munkacsi took it when visiting Seville to photograph the city's horse market. When making prints, he'd crop in on the sides, cutting off the third dancer and musician on the right.

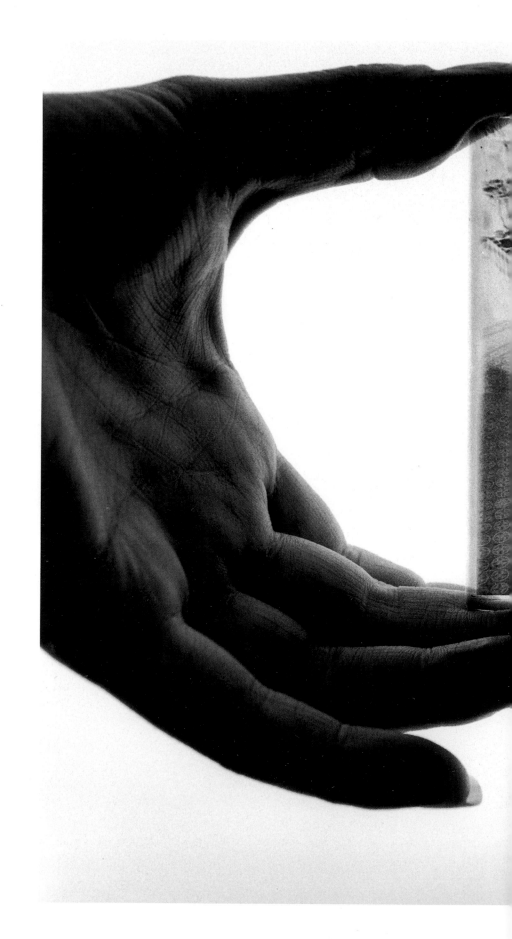

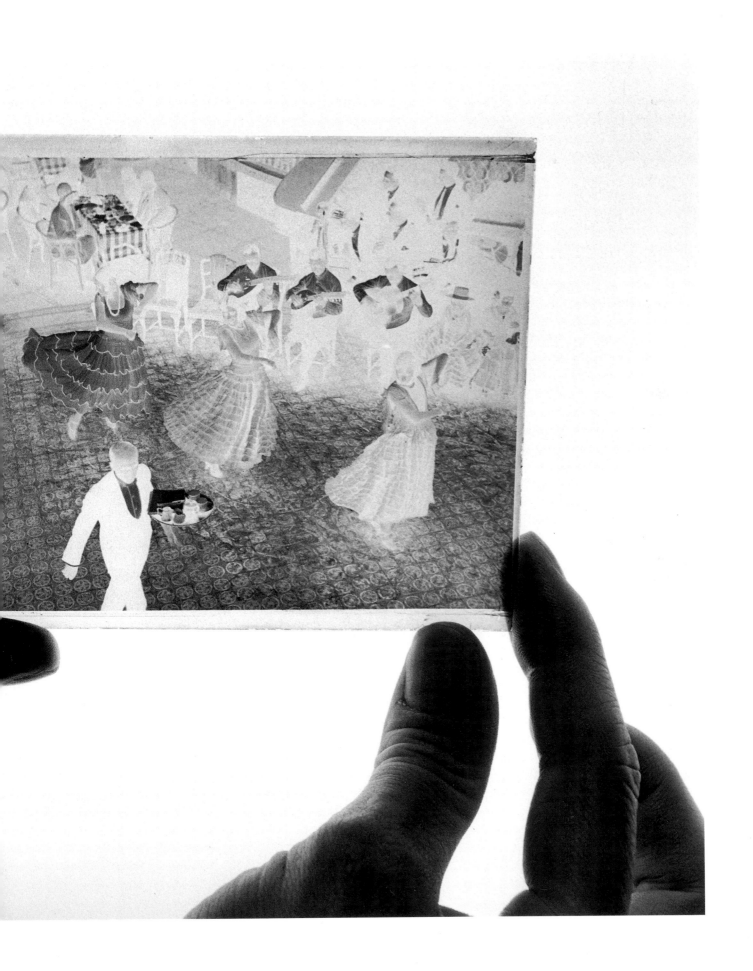

BARBARA MORGAN

Letter to the World (Kick), 1940

Dobbs Ferry, N.Y.

Hands: Lloyd Morgan
1/27/94

"My mother looked for the 'nodes'—the points where she felt thought and purpose and motion in the dance come together," says Doug Morgan. "She wanted a moment when the dancer defies gravity. She tried to catch a sense of levitation in her pictures."

Barbara Morgan felt that the high-speed flashes from a strobe light (just coming into use in 1940) made pictures too sharp. She preferred that a dancer's extremities be slightly blurred when caught in motion. She set the focal plane shutter of her Speed Graphic camera at 1/800th of a second and synchronized it to fire three General Electric #31 focal plane flashbulbs.

"Martha Graham reminisced about the whole day they spent in the 23rd Street studio," says Lloyd Morgan. "She said to Mother, 'You made me do it over and over until we had it right. I got so tired. After each picture, you'd go off and develop the film. I'd just lie down on the floor and take a nap.'"

Fluorescent ceiling lights in a printing plant owned by Morgan's sons shine on their mother's negative of Graham dancing *Letter to the World*.

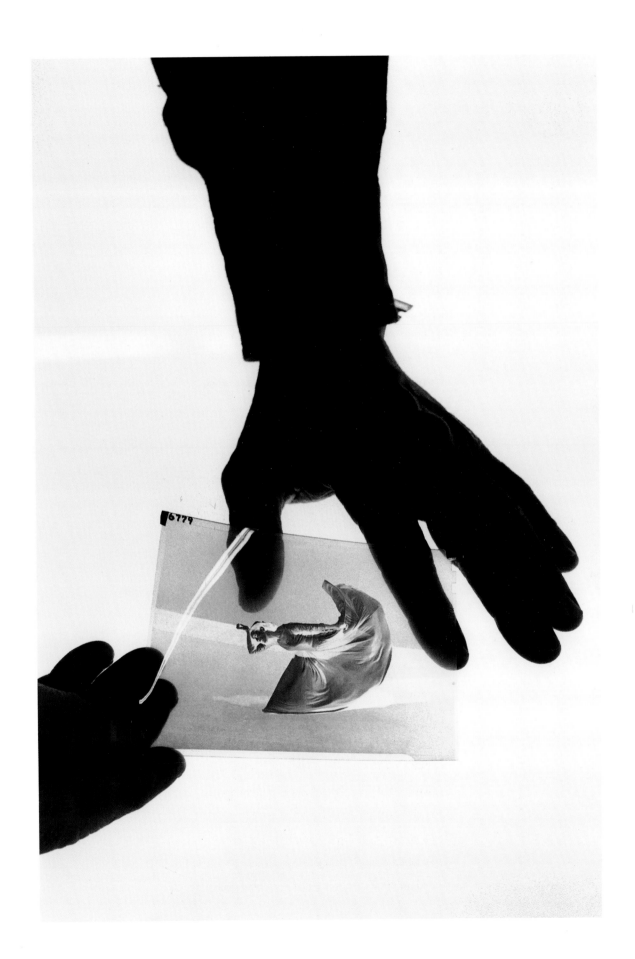

BILL BRANDT

Drawing Room in Mayfair, circa 1936

London

Hands: John-Paul Kernot
4/27/94

"Bill was an extraordinarily secret man," says his widow Noya Brandt. "No one was allowed to see his darkroom. But he used to get terribly excited about the whole thing."

Brandt was born into a well-to-do English banking family. In 1931, when he was 27, he began to document the behavior of the upper and lower classes with his camera. He often used his father's servants and other relatives' houses as subjects for the upper, and wandered the streets to photograph the lower. This photograph was taken at his aunt's home in Mayfair.

"Everyone has, at some time or other, felt the atmosphere of a room. I found atmosphere to be the spell that charged the commonplace with beauty," Brandt said in 1948. "We are most of us too busy, too worried, too intent on proving ourselves right, too obsessed with ideas, to stand and stare. We look at a thing and think we have seen it.

"What we see is often only what our prejudices tell us to expect to see, or what our past experience tells us should be seen, or what our desires want to see.

"Very rarely are we able to free our minds of thought and emotions and just see for the simple pleasure of seeing. And as long as we fail to do this, so long will the essence of things be hidden from us."

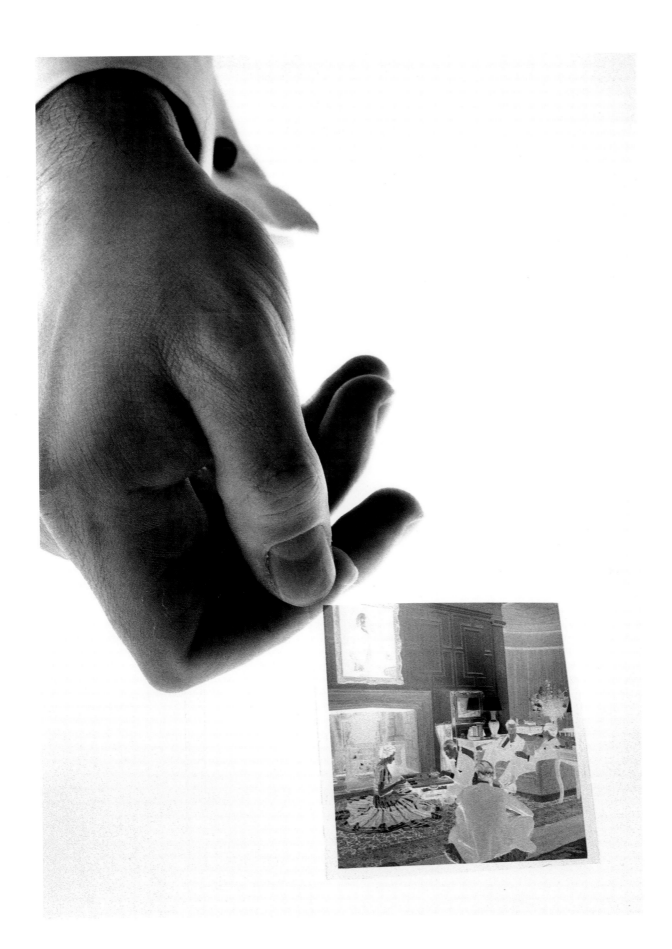

La Môme Bijoux, circa 1932

Paris

Hands: Gilberte Brassai
4/24/94

In 1932 Brassai walked into the Bar de la Lune in Paris, where he discovered La Môme Bijoux nursing a glass of red wine. "Her bosom was covered with an incredible quantity of jewelry: brooches, lavaliers, chokers, clips, chains—a veritable Christmas tree of garlands, of glittering stars. And rings! She wore more than a dozen," he wrote in 1976.

The photograph became (in part) the inspiration for the title character in Jean Giraudoux's 1943 play *The Madwoman of Chaillot*, and the basis for the play's costumes.

The year it was taken, a picture made from a similar negative was published in Brassai's book *Paris de Nuit*. His widow, Gilberte Brassai, says the publisher, Ars & Métiers Graphiques, first refused to return any of the negatives to the 65 published pictures and later claimed they were all lost. In 1984, Kim Sichel, an assistant professor of art history at Boston University, discovered them in the attic of the successor publisher in Paris.

Within a week of hearing the news, Brassai died. "I think his upset and astonishment at the discovery hastened his death," says Mme. Brassai, who did not get the negatives back until 1986.

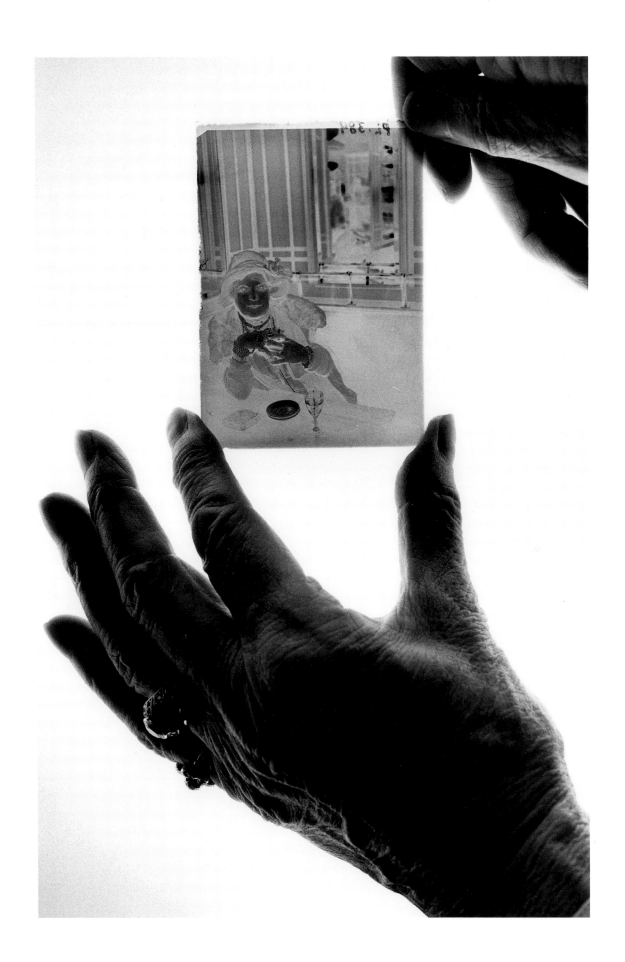

Louisville Flood, 1937

Time-Life Lab, New York City

Hands: Heike Hinsch
3/4/92

"The Louisville flood burst into the news almost overnight," wrote Margaret Bourke-White, who was in New York City at the time. "I caught the last plane, then hitchhiked my way from the mud-swamped airport. To accomplish the last stretch of the journey, I thumbed rides in rowboats and once on a large raft... Three-quarters of the city was inundated."

Four hundred people died. In a segregated part of town, Bourke-White photographed the National Association of Manufacturers' billboard as it loomed over residents patiently awaiting Red Cross relief supplies.

81

PAUL STRAND

New York, 1916 (top);
Orange and Jug on Porch, 1916
(middle); *Jug and Fruit*, 1916, and
Chair, 1916 (bottom)

Paul Strand Archives,
Millerton, N.Y.

Hands: Anthony Montoya
8/3/90

The fragility of glass negatives causes difficulty. Two of Paul Strand's best-known pictures, made within months of these four examples, are missing—possibly broken in one of Strand's frequent household moves.

Preserving film has problems too. In 1953 historian Beaumont Newhall wrote Strand with alarm to say that some flammable, nitrate-based film (in general use until the 1940s and replaced by acetate "safety film") was decomposing with age. Strand replied, "Thank you for your … rather horrifying letter about the impermanence and danger of nitrate film. I appreciate it even though my dreams will now take on a yellow-green jelly consistency. But seriously— what a shame to find Stieglitz and other negatives in this way. For years I fear photographers had the idea (I know I did) that nitrate would last and acetate tended to dry up. So I made efforts actually to get nitrate on special order. What an irony."

Since the '50s, proper methods for the storage of nitrate negatives have become widespread, and concerns have abated. "All photographic materials deteriorate over time," says Grant Romer, director of education at George Eastman House, "but their deterioration can be controlled with proper care."

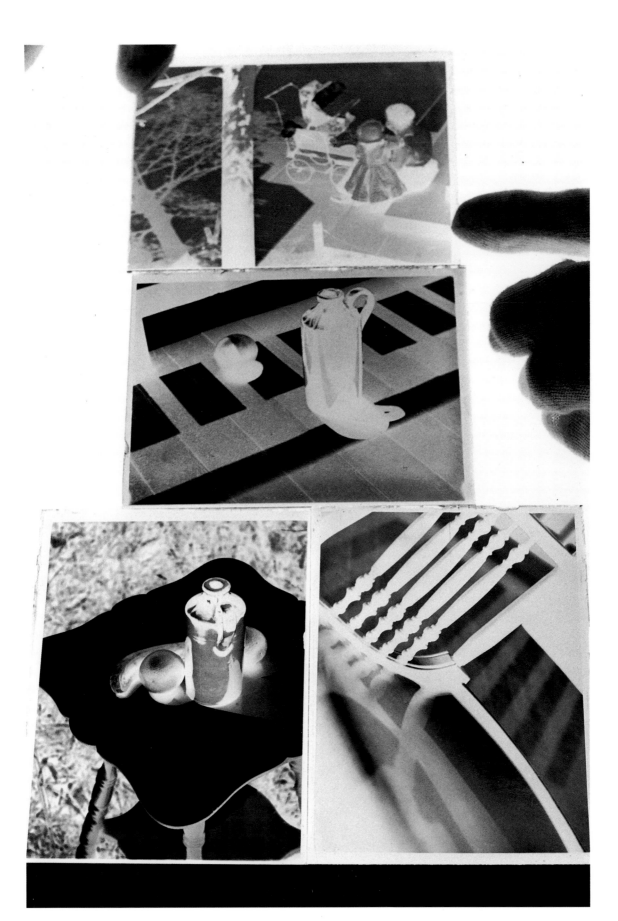

LOUISE DAHL-WOLFE

*Betty Threat Washing Her Hair
in a Japanese Bath,* circa 1954

Center for Creative Photography,
University of Arizona, Tucson

Hands: Amy Rule
8/20/93

On vacation in 1926, Louise Emma Augusta Dahl (whose mother heard it was good luck if a child's initials spelled a word) met a sculptor from Tennessee named Meyer Wolfe. They married two years later. "I kept my name but added Mike's because I loved him," she said.

Dahl-Wolfe's interest in photography became her profession in 1933 when she sold *Vanity Fair* magazine pictures of impoverished Tennessee women living in the mountains near her husband's home in Gatlinburg. After she moved to New York City, her work caught the eye of Carmel Snow, the new editor of *Harper's Bazaar*, and between 1936 and 1958, Dahl-Wolfe contributed 86 covers and thousands of fashion pictures and portraits to *Bazaar*.

When Snow retired, Dahl-Wolfe felt the fashion world was changing in ways she did not like. One day an editor presumed to look through the camera as she prepared to take a picture. Dahl-Wolfe quit on the spot.

She and her husband moved to their country house outside Manhattan. There, in 1989, at the age of 94, she died. "God meant me to be plain," said Dahl-Wolfe in 1940 about her place in the world of fashion. "Making a photograph is like cooking a meal. It can be done with taste, technique and feeling, but it isn't art."

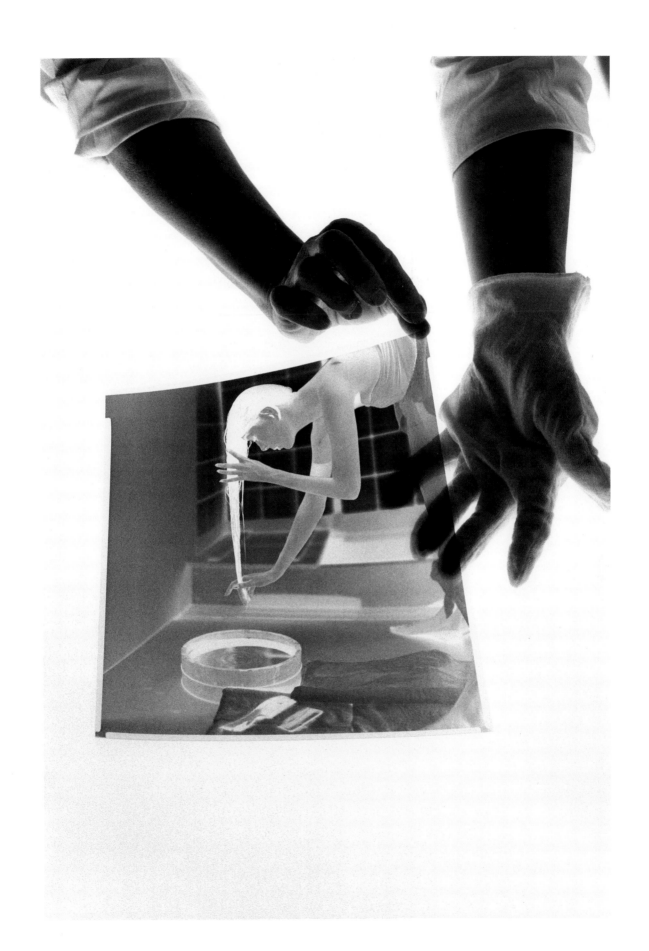

WEEGEE (Arthur H. Fellig)

The Critic, 1943

International Center of Photography,
New York City

Hands: Miles Barth
2/18/94

Arthur Fellig, known as Weegee, waited on the sidewalk as Mrs. George W. Kavanaugh (third from right) arrived for the start of the Metropolitan Opera's 60th season in New York City. Mrs. Kavanaugh apologized for wearing last year's jewels, but noted it was wartime.

The title of Weegee's picture (*The Critic*) comes from the expression of the woman on the far right. In the negative, however, facial expression is more abstract than in a print and therefore harder to read. Photographers often make contact prints simply to see such expressions clearly before deciding which negative to enlarge.

In prints Weegee cut out the three figures on the left. Because the Speed Graphic's viewfinder does not show the edge of a picture precisely, cropping became a standard procedure for news photographers who used the camera. Its 4 x 5 inch negative covers 20 square inches, meaning part of it can be easily enlarged without a loss of quality. In comparison, 35mm negatives cover only 1.5 square inches, and photographers avoid cropping them.

Weegee, who died in 1968, left his negatives to his good friend Wilma Wilcox, who gave them to the International Center of Photography on her death in 1993.

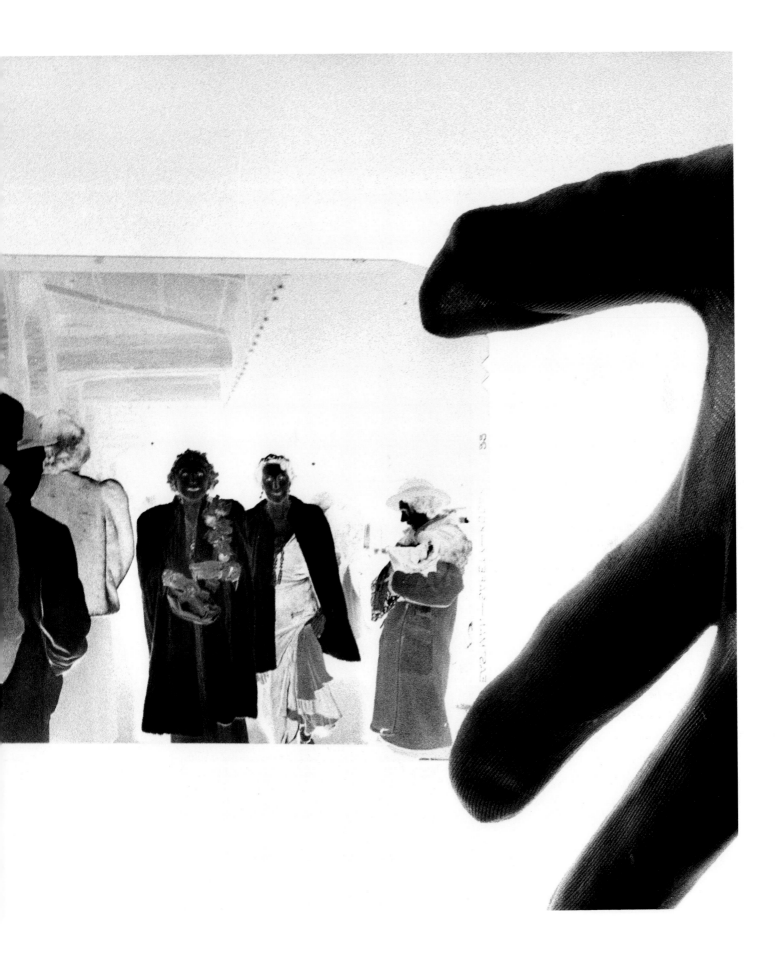

DOROTHEA LANGE

Plantation Owner
Near Clarksdale, Miss., 1936

Library of Congress, Washington

Hands: Jan Grenci
7/8/92

A strategy Dorothea Lange used when photographing for the Farm Security Administration was to bring along someone for her subjects to talk to. As often as she could in 1936, she brought her new husband Paul Taylor, an economist. In Clarksdale, Miss., his conversation shifted everyone's attention away from the camera and gave energy to an otherwise static situation.

Lange had a running battle with her boss, Roy Stryker. He wanted exposed film processed in the FSA darkroom in Washington. Lange wanted to develop and print her pictures at home in California. She won that right, but had to send the negatives to Stryker when she was done. That is why this piece of film showing a white plantation boss chatting in front of five black sharecroppers rests in the Library of Congress, not with Lange's nongovernment work at the Oakland Museum of Art.

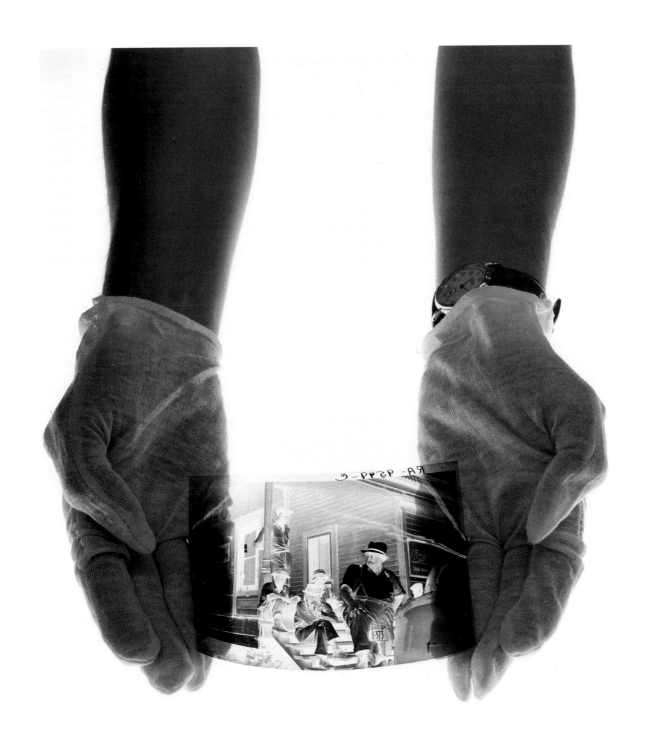

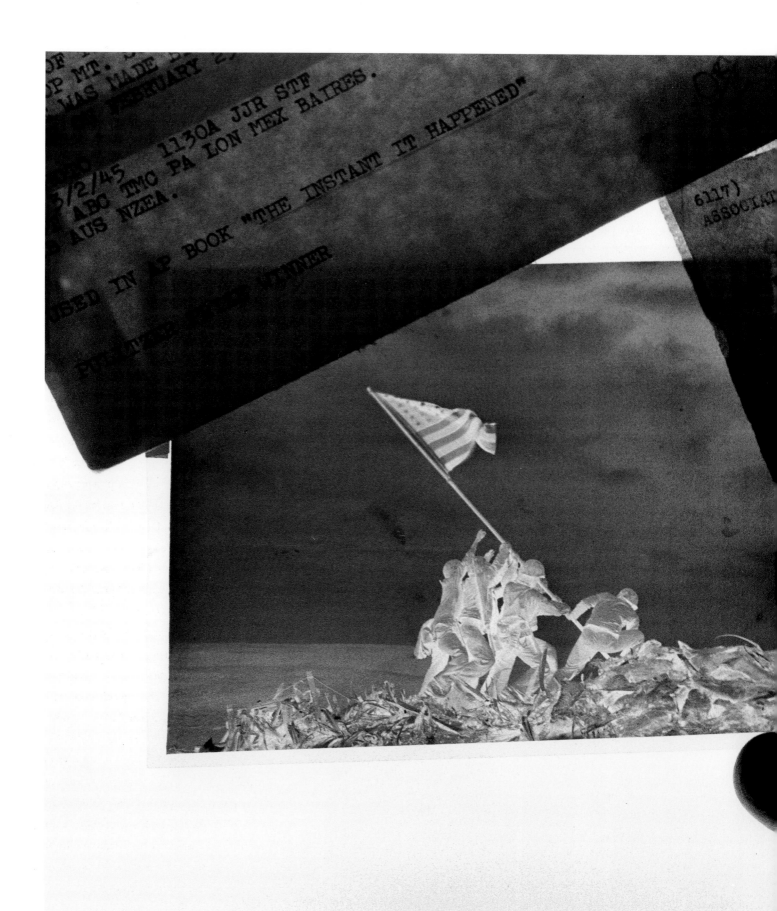

OF MT.
OP MT.
WAS MADE
FEBRUARY 2

3/2/45 1130A JJR STF
ABC TMO PA LON MEX BAIRES.
AUS NZEA.

USED IN AP BOOK "THE INSTANT IT HAPPENED"

PULITZER PRIZE WINNER

6117)
ASSOCIAT

Iwo Jima Flag Raising, 1945

Associated Press, New York City

Hands: Kevin Kushel
3/26/92

Four days after the landing on Iwo Jima, Joe Rosenthal of the Associated Press heard a rumor about "some guys going up the volcano" to replace the American flag flying there with a bigger one.

Rosenthal said that when he got to the top, "I stacked a couple of rocks to stand on because there was some brush in front of me, and I needed a higher angle. Sergeant Bill Genaust, with his movie camera, moved in across in front of me and then looked back to ask if he was in my way. I assured him that he was not. While we were playing Alphonse and Gaston, they started putting the flag up, and we just turned and pushed the button."

Rosenthal took two more pictures—of servicemen posed with the new flag—to finish his film pack, then "hiked to the beach, thumbed a ride on a passing boat...and got the film out on a seaplane that left for Guam every afternoon with the day's battle maps."

Later, when congratulated by those who had seen the photograph in newspapers across America, Rosenthal was not sure which picture they were talking about.

Three of the servicemen who raised the second flag died later in the battle, as did Sergeant Genaust. A statue carved as a replica of the photograph stands near Arlington National Cemetery in Virginia. Rosenthal received the Pulitzer Prize for photography, the only one ever awarded the same year a picture was taken.

HARRY BENSON

The Beatles, 1963

New York City

Hands: Harry Benson
8/20/94

"One of the Beatles—George, I think—was on the phone to some fan. John hit him with a pillow. I said, 'Do you do this often?' and they said, 'All the time.' But I didn't do anything about it at the time," wrote Harry Benson, who was covering the new group's tour in France for the London *Daily Express*.

"I waited until I had them alone with no other photographers around. I wanted to make sure their own photographer, Dezo Hoffman, was not there. I didn't want to give him any ideas. I never even told my reporter, 'The Beatles might have a pillow fight.' I didn't want it written about before I photographed it."

A few days later, after a performance, the Beatles' manager, Brian Epstein, came to the group's Paris hotel suite and announced that they'd make their first trip to the United States and perform on *The Ed Sullivan Show*.

"When Epstein left the room, I knew it was time. I said, 'How about a pillow fight?'"

RALPH STEINER

Ham and Eggs, circa 1934

Center for Creative Photography,
University of Arizona, Tucson

Hands: Amy Rule
8/20/93

"Today, if a negative does not print simply and easily, I throw it away," wrote Ralph Steiner in 1978.

"My life as an advertising photographer," he added, "was so coupled with tension and insecurity that as often as I could I mixed my work with humor. [This] is what I did to avoid certification to a mental hospital when told to photograph a plate of ham and eggs. In God's name, how does one photograph a plate of ham and eggs? My escape was to amuse myself."

WALKER EVANS

Photographer's Window Display,
Birmingham, Ala., 1936

Library of Congress, Washington

Hands: Jan Grenci
7/8/92

When he liked, Walker Evans cut up his
negatives to indicate the cropping he intend-
ed—or simply to fit part of an 8 x 10 inch
negative into his 5 x 7 inch enlarger.

"Stieglitz wouldn't cut a quarter-inch
off a frame," he said. "I would cut any inches
off my frames in order to get a better picture."

Evans sliced up two of his 8 x 10 inch
negatives of a photographer's display win-
dow, but a third lies uncut in Washington.
All were taken for the Farm Security Admin-
istration. Evans said he took the pictures in
Savannah, Ga. The government is sure he
took them in Birmingham, Ala.

In 1938 Evans used the photograph
as the second picture in his landmark book
American Photographs. For $12 the Library of
Congress still sells a print of it to anyone who
asks for one.

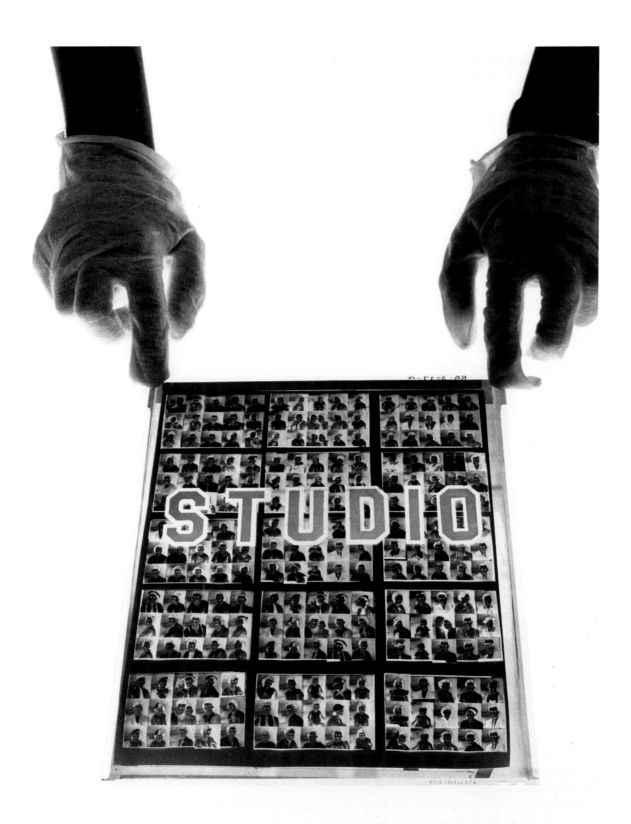

WYNN BULLOCK

Child in Forest, 1951

Center for Creative Photography,
University of Arizona, Tucson

Hands: Dianne Nilsen
5/15/92

Long after Wynn Bullock's photograph of his daughter was used in the "Family of Man" exhibition, his wife Edna told photographer Donna Conrad, "we got letters and phone calls asking, 'What did you have in mind when you photographed that child? Was that child supposed to be dead? Was she a statue that fell off into the world? Was she just left there after being molested?' And all Wynn could say was that here was a virgin piece of forest and why not have a virgin child down there. He couldn't believe that people could think those things."

FREDERICK E. BARSTOW

Glass Cracking, 1938

Littletown, Mass.

Hands: Gus Kayafas
2/23/93

The first negative ever made was a photo-
gram, not a photograph, because no lens was
used to make the picture. Henry Fox Talbot
put an object on a sheet of light-sensitive
paper, and its shadow formed the image.

In 1938 Frederick E. Barstow, an
M.I.T. graduate student working under Pro-
fessor Harold Edgerton's supervision, used
the same technique in order to see how glass
cracked. With a sheet of film underneath,
Edgerton wrote, "a spring-driven metal
plunger [struck] the glass with enough force
to break it." The contact of the plunger with
the glass set off a flash of less than one-mil-
lionth of a second's duration.

By comparing negatives produced
by flashes timed to go off at various intervals
after the plunger came down, Barstow and
Edgerton determined that cracks raced out-
ward from the center at about six times the
speed of sound, or about 1/16th of an inch in
a millionth of a second—the same speed de-
termined by "a German investigator who
used bullets. [This] indicates that the rate of
cracking is independent of the rate of applica-
tion of the breaking force," Edgerton noted.

SEBASTIAO SALGADO

*Gold Mine, Serra Pelada,
State of Pará, Brazil,* 1986 (top);
Greater Burhan Oil Field, Kuwait, 1991

Paris

Hands: Sebastião Salgado
3/31/93

Sebastião Salgado decided to document manual labor as it exists in a mechanized world and began by photographing 50,000 bee-like workers searching for gold in an open pit mine at Serra Pelada, Brazil.

Since then he has photographed workers harvesting sugarcane, catching tuna, refining titanium, assembling bicycles, slaughtering pigs, and digging a tunnel under the English Channel.

"I went to Kuwait after the war with Iraq, when the oil wells were still burning and flowing out of control," he wrote. "The war had ended just 30 days earlier, and the entire region was covered in oil: clouds of burned oil darkening the sky, lakes of oil polluting the land." In the Greater Burhan Oil Field, workers spent a week replacing an old wellhead damaged by Iraqi explosives.

Silver tape masks the blank edge of the negative to prevent light spilling through it and darkening the sky in the print.

W. EUGENE SMITH

Dr. Albert Schweitzer, 1954

Center for Creative Photography,
University of Arizona, Tucson

11/78

W. Eugene Smith explained that errant light had severely fogged his film and almost ruined his picture of Albert Schweitzer. Several days' effort in the darkroom, he said, had produced a good print. A negative taken of that print, rather than the original negative, is used to make all new copies of the picture.

"The copy negative is a little harsher than the original," Smith said, "but I can probably get a print from this negative in an hour instead of five days and five nights."

In fact, the original negative (frame #38) is unblemished. However, it does not show a hand and a saw, which have appeared in silhouette at the bottom of the picture ever since it was first published in *Life* magazine in 1954.

Presumably Smith added these elements from other negatives to improve the picture's composition. Doing so does not change the picture's content in any significant way; but the editors at *Life*, with their journalistic set of mind, would probably not have published the picture knowing it was a composite, and this may explain why Smith did not describe exactly what he had done.

Moonrise, Hernandez, N. Mex., 1941

Carmel Highlands, Calif.

5/84

"I observed a fantastic scene as we approached the village of Hernandez," wrote Ansel Adams in his autobiography. "I steered the station wagon into the deep shoulder along the road and jumped out…yelling [at my companions], 'Get this! Get that, for God's sake! We don't have much time!'

"After the first exposure I quickly reversed the 8 x 10 film holder to make a duplicate negative…but as I pulled out the slide the sunlight left the crosses and the magical moment was gone forever." It was Oct. 31, 1941, just after 4 p.m.—Halloween. Adams had his treat. "I knew it was special when I released the shutter," he said.

"During my first years of printing the *Moonrise* negative, I allowed some random clouds in the upper sky area to show, although I had visualized the sky in very deep values and almost cloudless," he added.

Shortly after Adams' death in 1984, his widow Virginia posed with the negative on a light box (far left) along with the cloudy and relatively cloudless prints made from it.

BRETT WESTON

Negatives, Burned at His 80th
Birthday Celebration

Center for Creative Photography,
University of Arizona, Tucson

Hands: Dianne Nilsen
5/15/92

When Brett Weston invited the press to his
80th birthday party in Carmel, Calif., he said
he would burn his negatives as part of the
celebration. Dianne Nilsen came up from the
Center for Creative Photography in Tucson
with the hope of changing his mind.

"The day before the party, Brett and
his brother Cole had hosed down 1,500 of
Brett's early negatives in a garbage pail," says
Nilsen. "They chose 12 negatives to save.
Cole had used a paper punch to put a hole in
each corner and with a grease pencil wrote
'No prints' across each one." Nilsen asked
Weston's permission to catalogue the emul-
sion codes notched on the edges of the
remaining film.

"On his birthday I began to log in
the emulsion codes as Brett started to burn his
work in the fireplace," says Nilsen. "Pleading
that I could not keep up with him, I said,
'Brett, do you have to destroy them all today?'

"'Well, no, honey. I don't,' he an-
swered, and stopped."

After the party—and after giving
Nilsen permission to return to Arizona with
50 undamaged 8 x 10s, a dozen 11 x 14s, and
a Ziploc freezer bag of ashes—Weston left for
his house in Hawaii. He did not finish de-
stroying his work before his death in 1993.

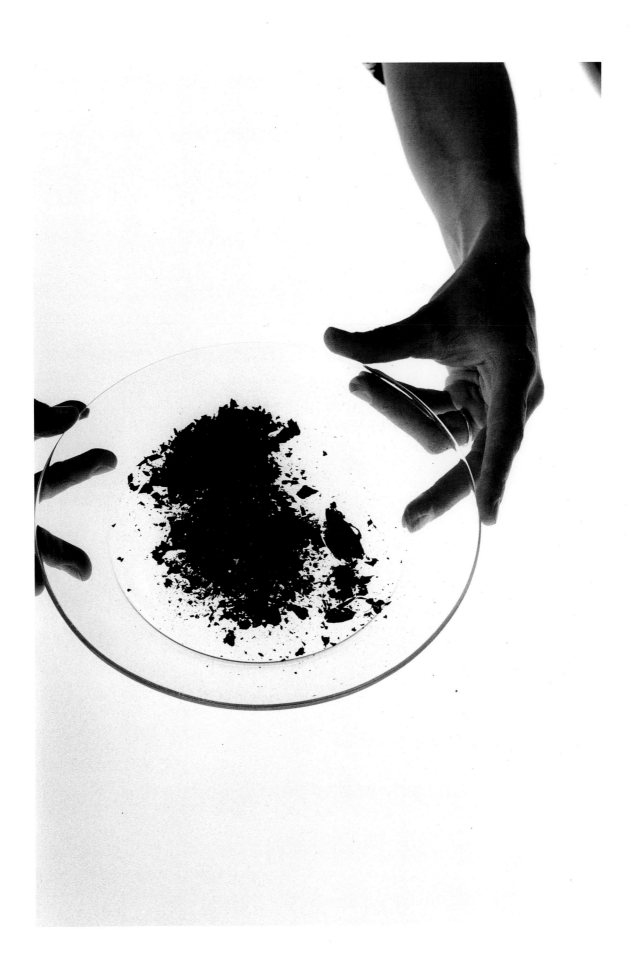

Notes & Commentary

A Short History of the Negative

In February 1839, Louis Daguerre told the public in Paris how to make a photograph. He explained that he took a copper plate, coated it with silver, and exposed it to iodine fumes. On the plate's surface, iodine combined with the silver to produce a salt, silver iodide. Such silver salts break down on exposure to light, a principle essential to making photography work. Three weeks later in London, after hearing reports of Daguerre's announcement, Henry Fox Talbot rushed to demonstrate his own process. Talbot dipped a piece of paper in silver nitrate. When this dried he brushed the sheet with saltwater, forming silver chloride on its surface. Silver chloride also reacts to light. Both men stopped the process (the key to making photography practical) with a wash in saltwater because, oddly enough, table salt in larger quantities than Talbot brushed on his sheet to begin with will desensitize silver salts to light.

Talbot's paper negatives are translucent and can be used to make an unlimited number of prints (an impossibility with opaque daguerreotypes). However, prints by Talbot's process are not sharp or detailed, while daguerreotypes, which are negatives too (they look positive only when held to the light at a certain angle), are crystal clear.

Sculptor Frederick Scott Archer noticed in 1851 that collodion (a sticky mixture of guncotton, alcohol and ether) could hold silver salts and be poured onto glass. Negatives on glass could be used to make paper prints as clear as daguerreotypes. Both Talbot's and Daguerre's processes were soon obsolete. Unfortunately collodion negatives, known as "wet plates," must be prepared on the spot and exposed while the plate is still damp, thus requiring a darkroom near the camera when an exposure is made. This is no problem in the studio but requires considerable effort when the camera is used outside.

In 1878 "dry plates," which could be prepared in a factory and used anywhere, were marketed. Ten years later, celluloid began to replace heavy, fragile glass as a base. Since celluloid is flexible, film could be manufactured and easily processed in rolls, leading to the development of today's small, precision hand cameras.

While still photography is on the edge of an electronic revolution, virtually all photographs made today, even color slides and Polaroid materials, are made using the principles discovered by Daguerre and Talbot.

The Latent Image

Daguerre's first plates, made long before his process was ready for the public, were so insensitive to light that exposures took more than an hour (as they also did with Talbot's process), and the system was impractical for depicting living subjects. Daguerre discovered that fumes from heated mercury coming in contact with a partially exposed plate caused an image to appear where none was apparent before. Using this principle he reduced his exposure time to minutes. Talbot adapted the notion as soon as he read the public description of Daguerre's process, using a solution of gallic acid (widely found in plants and used in making leather) to bring out a latent image in his partially exposed paper. The sight of an image appearing on a blank sheet of paper as it sits in a developer still seems magical.

My Selections

I have not photographed every negative I might like to see. Some guardians find the idea too bizarre to consider. Other negatives are not available; most of those taken by Julia Margaret Cameron and Roger Fenton, for example, are simply missing. Even when I find a negative I want, I'm often shown other interesting negatives as well—ones I never thought to ask about. Clearly, chance has guided my selections.

Also, by looking for negatives to photographs that are considered classics, I've favored the past over the present. Therefore, this book is merely a sampling of existing riches, but that is what I intended it to be.

The hands holding each negative belong to the photographer or someone responsible for its care (except in one case, where I held it myself). I have listed with each photograph where the negative is kept and the date I photographed it.

In print, of course, true reproduction of a negative is impossible because the page is not transparent. However, the solid appearance negatives take on here helps focus attention on them as objects. I want to do that.

ON PRINTING

Some photographers, like Ansel Adams, W. Eugene Smith and Paul Strand, have understood the printing process well. They take their pictures with the final print in mind and plan its tones to fall as dictated by the play of light upon the subject in clear, dramatic and often breathtakingly beautiful patterns. Their best prints are the finest expression of their photographs, much as a great performance of *Richard II*, rather than the script alone, is the finest expression of Shakespeare's play.

Other photographers (Henri Cartier-Bresson and André Kertész come to mind) hire professional printers to provide a smooth rendition of the tone and detail of their negatives. Igor Bakht, who printed all of Kertész's work after 1964, makes prints that have a beautifully harmonized range of middle tones. His style draws out the information in the negative without changing the picture's meaning.

When making a print, a photographer withholds light from some areas of the paper and gives extra exposure to others, in order to darken or lighten a detail or an area of tone in the picture. He does this by moving his hands over the paper as it is exposed to light, and he does this often because printing papers routinely record a narrower range of brightness than the negative does.

The print will show, through small gradations of gray, exactly the way light fell upon the subject. The print's scale of tone—emphasizing its dark, middle or light tones—will establish the picture's mood. Balancing all these tones may take a number of tries, and it is not until the print has dried, after an hour's wash, that the photographer can be sure he has what he wants.

Most photographers add nothing to the negative when making prints, but they may remove details—by cropping or by darkening certain dark areas to black. Often they will return to negatives at different times in their lives and make different kinds of prints. Late in his life Alfred Stieglitz printed negatives on silver-based paper, although as a younger man he had used platinum- or palladium-based paper—or even printed them directly onto photogravure plates. Each of these prints is expressive. Each picture is subtly different and clearly the same.

The paper a photographer chooses helps to determine the number and spacing of tones in the final print. It also determines the color of black (brownish, bluish, greenish or jet) and white (warm, creamy, stark, etc.). The texture of the paper's surface (glossy, matte, canvas, etc.) affects the way light is absorbed by the print when viewed. Different developers and toners may modify the paper's color; but while choices are numerous, photographers usually choose a single paper, developer and toner (if any) and stick with them. Professional photographers often use the same materials as the most inexperienced amateur.

Machines, of course, can make prints automatically (just as they play musical instruments or chess and pitch baseballs) and do it fairly well, but they translate the negative to positive quite literally.

Ironically, Brett Weston, who made thousands of prints from his father Edward's negatives, concluded that one photographer should not print another's work. "It's just too personal," Weston said. "It's partly a matter of mood. You have to work with enthusiasm. When I'm back from the field, I like to hit the darkroom that night and print the next morning. The continuation of the flow of excitement is very important, and I'm always excited in the darkroom."

•

SOURCES

Unless noted here, all quotations are from conversations with the author during the preparation of this book.

p.8: "There was...on the left," Henri Cartier-Bresson, *The Decisive Moment*, Simon and Schuster, New York, 1947.

p.10: Peter Pollack, *The Picture History of Photography*, Harry N. Abrams, Inc., New York, 1958, p.306

p.12: Nancy Newhall, *The Daybooks of Edward Weston*, Vol. 2, Horizon Press, New York, 1966, pp.179-181; number of prints: Amy Conger, *Edward Weston: Photographs from the Collection of the Center for Creative Photography*, University of Arizona, Tucson, 1992.

p.14: A.D. Coleman, "Man Ray," *Art News*, January 1977, p.52.

p.18: Alvin Langdon Coburn, *An Autobiography*, Frederick A. Praeger, New York, 1966, p.84.

p.20: "I will be remembered...remembers that," Barbaralee Diamonstein, *Visions and Images*, Rizzoli International Publications, New York, 1981, p.54.

p.22: Carl Chiarenza, *Aaron Siskind: Pleasures and Terrors*, New York Graphic Society, Boston, 1982, pp.65, 149.

p.28: "Nickolas Muray," *The Complete Photographer*, June 1943, pp.63-67.

p.30: I had a deep conviction...negatives," Margaret Bourke-White, *Dear Fatherland, Rest Quietly*, Simon and Schuster, New York, 1946, p.77; "Using the camera ...front of me," Bourke-White, *Portrait of Myself*, Simon and Schuster, New York, 1963, p.259.

p.34: Estelle Jussim, *Stopping Time, The Photographs of Harold Edgerton*, Harry N. Abrams, New York, 1987.

p.37: "We had...take a picture," "Harry Callahan," Hallmark Cards Inc., 1981.

p.39: Daile Kaplan, *Photo Story—Selected Letters and Photographs of Lewis Hine*, Smithsonian Institution Press, Washington, 1992, p.49.

p.40: The negative is from the estate of Dmitri Baltermants. "The Eye of a Nation," *Life*, July 1992, pp.89-94.

p.42: "The empty...that boat," Robert Capa, *Slightly out of Focus*, Henry Holt & Co., New York, 1947, pp.148-51.

p.46: Harold E. Edgerton and James R. Killian Jr., *Flash! Seeing the Unseen by Ultra High-Speed Photography*, Charles T. Branford Co., Boston, 1939, pp.45-46.

p.48: "Papa...*everything*," Ezra Bowen, *Jacques-Henri Lartigue*, Aperture Inc., Millerton, N.Y., 1976, p.7; "Women...fascinates me," "Beauty's Face," *Life*, Fall 1988, p.86; "I'm seven...the weeds," "Shooting Past 80," *Life*, May 1982, p.116.

p.50: "Speaking of Pictures," *Life*, Feb. 28, 1949, pp.15-16.

p.54: Barry B. Combs, *Westward to Promontory*, American West Publishing Co., Palo Alto, Calif., 1969, pp.68, 77.

p.56: "Number 3...wear it again," Sheryle and John Leekley, *Moment: The Pulitzer Prize Photographs*, Crown Publishers Inc., New York, 1982, p.26.

p.60: "It was an act...devoured me," Yousuf Karsh, *In Search of Greatness*, Alfred A. Knopf, New York, 1962, p.67.

p.70: "Her *Magnolia*...we hadn't," Judy Dater, *Imogen Cunningham*, New York Graphic Society, Boston, 1979, p.61.

p.72: "Martin Munkacsi," *Universal Photo Almanac*, Falk Publishing Co. Inc., New York, 1951.

p.76: "Everyone has...a room," David Mellor, "The Brandt Files," *Camera Arts*, May 1983, p.6; "I found...from us," John Szarkowski, "Bill Brandt," *Album*, February 1970, p.12.

p.78: "Her bosom...dozen," Brassaï, *The Secret Paris of the '30s*, Pantheon Books, New York, 1976.

p.81: "The Louisville flood...," Margaret Bourke-White, *Portrait of Myself*, Simon and Schuster, New York, 1963, p.149.

p.82: Sarah Greenough, *Paul Strand, An American Vision*, Aperture Foundation Inc., New York, 1990, p.128.

p.84: "I kept...loved him," *A Photographer's Scrapbook*, St. Martin's/Marek, New York; "God meant...isn't art," "Photographing Fashion," *Look*, July 16, 1940, pp.16-17.

p.91: Jon Brenneis, "Joe Rosenthal and Number Ten from Iwo," *ASMP Bulletin*, July 1987, p.1.

p.92: Harry Benson, *The Beatles in the Beginning*, Universe Publishing, New York, 1993, p.42.

p.94: Ralph Steiner, *A Point of View*, Wesleyan University Press, Middletown, Conn., 1978, pp.48, 58.

p.96: *Walker Evans at Work*, Harper & Row Publishers, New York, 1982, p.139.

p.98: Donna Conrad, "A Gathering of Friends: An Interview with Edna Bullock," *Camera & Darkroom*, February 1993, pp.38-45.

p.100: Harold E. Edgerton and James R. Killian Jr., *Flash! Seeing the Unseen by Ultra High-Speed Photography*, Charles T. Branford Co., Boston, 1939, pp.136-137.

p.102: Sebastião Salgado, *Workers*, Aperture Foundation Inc., New York, 1993, p.17.

p.104: "The copy negative...," Eleanor Lewis, *Darkroom*, Lustrum Press, Rochester, N.Y., p.149.

p.106: Ansel Adams, *An Autobiography*, Little, Brown and Co., Boston, 1984, pp.273-275.

p.108: *Brett Weston, Photographs from Five Decades*, Aperture Inc., Millerton, N.Y., 1980, p.59.

INDEX